IMAGES
of America

SEDONA

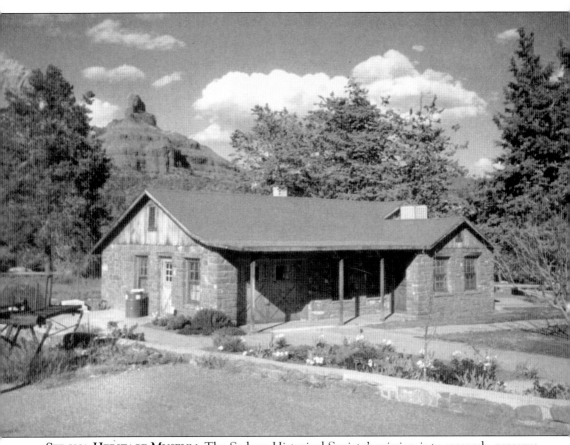

SEDONA HERITAGE MUSEUM. The Sedona Historical Society's mission is to research, preserve, and teach the history of Greater Sedona. As part of that effort, the society operates the Sedona Heritage Museum at 735 Jordan Road in Uptown. The society seeks to preserve the artifacts and the essence of the way of life experienced by Sedona pioneers from 1875 to the present. The museum's exhibits include stories of area pioneers, movies made in Sedona, cowboy life, vintage vehicles, and antique orchard and fruit-processing equipment. The red rock home and fruit-packing sheds are on the National Register of Historic Places. The Sedona Historical Society is a nonprofit 501c3 organization whose efforts are entirely funded by the generous support of members and sponsors. For more information about membership, programs, and the museum, call 928-282-7038 or visit the Web site at www.sedonamuseum.org.

ON THE COVER: The original Schnebly homestead is pictured shortly after being built in 1901. The two-story house became the area's original bed-and-breakfast. The Owenby irrigation ditch, which crosses the property, still runs through Los Abrigados and an adjacent neighborhood.

IMAGES
of America

SEDONA

Lisa Schnebly Heidinger, Janeen Trevillyan,
and the Sedona Historical Society

Arizona Historical Foundation

ARCADIA
PUBLISHING

Published by Arcadia Publishing
Charleston SC, Chicago IL, Portsmouth NH, San Francisco CA

Printed in the United States of America

Library of Congress Catalog Card Number: 2007923093

For all general information contact Arcadia Publishing at:
Telephone 843-853-2070
Fax 843-853-0044
E-mail sales@arcadiapublishing.com
For customer service and orders:
Toll-Free 1-888-313-2665

Visit us on the Internet at www.arcadiapublishing.com

*To Paula Schnebly Hokanson, my aunt and a longtime member
of the Sedona Historical Society, for generously sharing her heritage,
hours, and heirlooms with so many.*

—Lisa Schnebly Heidinger

To Laura Purtymun McBride, founder of the Sedona Historical Society.

—The Sedona Historical Society

CONTENTS

ACKNOWLEDGMENTS

Sedona and T. C. Schnebly died before I was born; their son Ellsworth was my grandfather. I grew up with his pride in the town, but his stories were not even history yet.

Being in Sedona meant walking down to Grandfather's creek property, and while he industriously inspected and puttered, my father, Larry, showed us how to skip rocks and spot skeeterbugs skimming across the surface of the water. It meant watching my grandmother Lucille work in the garden. She picked up Sedona Schnebly's custom of building terraces from red rocks, and her roses are still growing at her last house.

The town has changed, but there is room for all of us to create memories. My husband and I were married on the bank of Oak Creek where Sedona and T. C. had lived a century before. Our children have tested their nerve and coordination scrambling around rock formations on Schnebly Hill Road. As our collective memories move toward history, it is good to have many of the earliest compiled in one place. I am grateful to Christine Talbot and all at Arcadia Publishing for making this book possible, as well as Jared Jackson for his talent and humor.

—Lisa Schnebly Heidinger

The Sedona Historical Society–Sedona Heritage Museum would like to recognize volunteer Janeen Trevillyan for taking on the society's effort toward this book. Janeen has been an involved society member since 2000. Of her endeavors, Janeen says, "Sedona is rather unique in that here you can still interview someone who personally knew their town's first settlers. This project has been a gift to me, not a chore on behalf of others."

Thanks also go to all the members of Sedona-area pioneer families and longtime residents who have shared their photographs, stories, and artifacts with the society. Because of them, we could actually take on a project such as this.

Special thanks go to Sherman Loy, Loretta Benore, Al Clem, and Valerie Girard for providing special assistance.

We believe that collectively the individual contributions of Sedona settlers and community builders have advanced this wondrous place. Their legacy is that the word *Sedona* is synonymous with "pride of place."

—The Sedona Historical Society

Finally, please know that we did everything in our power to "get it right," and we apologize if there are any errors or omissions. Unless otherwise noted, all photographs appear courtesy of the Sedona Historical Society. Photographs in chapter two are part of the Schnebly family collection.

INTRODUCTION

Oak Creek Canyon is often described as "God's Country." Adjectives seem inadequate trying to explain the liquid brilliant blue of the sky and the warm shades of red rock, riveted with rusty stains where water has flowed for millennia. In fact, being one of the few year-round sources of water in Arizona has played a role in virtually all of Sedona's development. Early residents relied on Oak Creek, some building irrigation systems not only to provide for their families and livestock, but also to grow crops that became important in the area's commerce. The creek also helped Sedona become a mecca for tourists from the earliest days. And even the layout of the roads depended on what routes carved out by early residents could be best navigated during high water.

The geology that makes Oak Creek so distinctive is shaped by the sandstone, which began forming half a billion years ago, when what is now Arizona was at the bottom of a sea. When the Colorado Plateau separated from lowlands several million years back, it was nature's artists—water and wind—that gradually sculpted formations out of the rock, laced with iron oxide to provide the warm colors so much a part of the local scenery.

Not until about 6,000 years ago did humans inhabit the area. Nomadic tribes of hunters and gatherers settled first. Then around the first millennia, the ancestors of some of the West's contemporary tribes arrived. Now referred to as Sinaguas ("without water" in Spanish), they created dwellings from sandstone. Some cliff houses in Boynton Canyon and around Sedona are still visible, constructed in excellent observational and defensive positions. The early residents also left enigmatic petroglyphs, carvings, and pottery. Until the early 20th century, before the public was conscious of the need to preserve archeological finds, pieces of ceramic and arrowheads lay widely scattered for hikers to collect. Then several hundred years ago, the Yavapai Apache tribes arrived around the time that the Sinaguas migrated out. They are the ones who planted the crops at what is now known as Indian Gardens.

Following the Native Americans, the next owners of Oak Creek Canyon were absentee landlords. The Spanish held most of today's southwestern United States until Mexico became its own nation in the early 1800s. The Gadsden Purchase and the Hidalgo Treaty created what is now Arizona later in the century.

The first Anglo settler in Oak Creek Canyon was a man named John James Thompson. His early life sounds like the writing of an 18th-century novelist. Born in Londonderry, Ireland, in 1842, Jim Thompson struck out at the age of 14 to make his way in the world. Thompson was able to talk his way onto a ship bound for New York from Liverpool by convincing a young man to purchase him passage as his younger brother. Various adventures greeted the new immigrant, and he traveled widely before coming to Arizona Territory.

Thompson worked in Prescott and came across Indian Gardens in 1876, shortly after the last Apaches left. The crops included the Native American "three sisters" of squash, corn, and beans. Posting a notice stating "Squatters Rights" on a pine tree, Thompson built a log cabin and became the first white man to permanently reside in Oak Creek Canyon. Another early resident

was Jessie "Bear" Howard. The names of other settlers in the 1880s include Adolph Willard, John Thomas, William Dyer, Henry Schuerman, Jack Robinson, and John Lee. Of these, only Schuerman remained to make lasting contributions to the community.

The next wave of settlers included Armijos, Chavezes, Purtymuns, Jameses, and Owenbys. Along with irrigating crops, some residents fished, trapped, and hunted to scrape out a living. Perhaps the most famous resident of Oak Creek is the woman whose name it bears: Sedona Miller Schnebly. Born in Missouri in 1877, Sedona married T. C. Schnebly and moved West with him on the advice of his brother, a teacher in Oak Creek. T. C. began growing produce and selling it in Flagstaff. He would bring notions and mail back to local residents on return trips.

In the 1920s, the Jordan family came, destined to contribute much to the new town. Brothers Walter and George farmed both separately and together to grow peaches and apples, which gained a large and widely distributed market. Most Sedona residents in the 1930s worked for the Jordans at some point, pitching in to help with picking, sorting, and shipping the produce around Arizona and the West.

Various residents built sections of roads to make transportation easier—from Jim Thompson hacking out a steep trail to the rim of Oak Creek Canyon, known as Thompson's Ladder, to local road crews blasting a tunnel in the canyon through the red rock. This was later replaced with the construction of State Route 89A.

Still mostly unpaved, an alternate route out of the canyon is Schnebly Hill Road. A stretch of it passes through rolling grassland, punctuated by pine trees. An early venture here was a ranch called Foxboro. For a while, it was a ranch camp for boys from the East. Kel Fox, the son of the family, remembered that other young men searching for adventure would come around asking for work while they explored Arizona. He told of one young man, eager and earnest, who could not seem to get the hang of ranch work. He could not stay on a horse! During his spare time, he took photographs and after a few weeks went on his way. "Later on, he sent some of his pictures," Fox said. "He'd photographed the house, the scenery, some of us. I wish I knew what had happened to those—not everyone has Ansel Adams photographs of their home."

During the lean years of the Great Depression, road work fed a few families. It eventually provided more than just jobs for local men; having roads built and improved made Oak Creek Canyon much more readily accessible when, after World War II, Americans discovered the joys of motoring. Tourists contributed much to the area's economy and continue to do so today.

Sedona stayed a small town until the 1950s. At that time, the discovery of an underground aquifer in what was called Grasshopper Flat (now West Sedona) made development possible. Some original homesteads could be sold, but once those had been purchased, land had to be acquired by working out trades with the Forest Service. There had been a Forest Service headquarters in Sedona since 1905, and the relationship between town and government agency was valuable.

Now Sedona had a few amenities to draw the tourists, which would later provide the town's primary source of commerce. The first hotel was Mary Sisson's two-story hunting and fishing lodge, which became known as the Lolomai. In 1925, Carl Mayhew opened Mayhew's Oak Creek Lodge. The lodge's guest book was a veritable "who's who" of celebrities, movie stars, and politicians. When the lodge burned down in 1980, it was owned by the Forest Service, and the decision was made to let some ruins crumble on their own. After that, visitors to West Fork could gaze at the crumbling walls, rock work, and outbuildings—a poignant elegy of an elegant landmark.

After Uptown literature became a popular craze, the area's "screen test" came with the movie version of Zane Grey's famous book *Call of the Canyon*, set in Oak Creek Canyon and made as a silent film in the mid-1920s. Victor Fleming directed. This film was shot at the entrance to West Fork. Studio workers remodeled an existing cabin into a major set element, a ranch house. Stories linger of flash floods shutting down production for several days, while cast and crew scattered among local families as unexpected guests. The film sent a siren song to other directors who wanted the splendid scenery for their own works. One of the earliest was *Riders of the Purple Sage*, shot in 1931 with George O'Brien. Maureen O'Sullivan first came to Oak Creek to appear in *Robbers Roost* the following year.

It was not until the 1970s that a new element of Sedona's artistic life was created: Tlaquepaque. Abe Miller was a Las Vegas businessman with an artist's soul who, during his extensive travels, reconciled two of his favorite areas—Oak Creek and Mexico—into one idea: a collective of about 40 studios where artists could create and sell. Miller enlisted unconventional architect Bob McIntyre, flying him around Mexico in his plane. The two would seek out villages and spend days sketching, photographing, and just observing the plaster, tile, iron, and landscaping that exemplified the flavor of Mexico. They returned to Oak Creek to the property Miller had acquired, which had been first the Owenby and then the Schnebly homestead years before. The massive sycamore trees on the property had to be preserved, which meant much altering or complete abandoning of layouts and straight lines. Miller's guidelines included a small chapel, said to be his favorite spot in the development. McIntyre's credo was "forget the plumb, use the thumb." Regarded as eccentric by many, he was known to order anything too symmetrical to be torn down and reconstructed with less rigid lines.

Tlaquepaque introduced a new kind of enterprise to Sedona. Until then, construction had been primarily practical. This exposed residents to the idea of architecture as artistic as the merchandise inside. It was this ethos that led Sedona to place more emphasis on zoning and controlling the architecture of new construction. The town later became the only place in the world with a McDonald's replacing the standard golden arches with teal. Old-timers were becoming fewer and farther between. In 1968, the Sedona Westerners became the first to set about collecting memories of pioneers. They published a book entitled *Those Early Days*, with oral histories and essays collected from founding families and community contributors, covering many aspects of a vanishing lifestyle. Then in 1982, the Sedona Historical Society was formed, now occupying the town's historic Jordan farmhouse.

Events and celebrations draw both tourists and townspeople. It is a fitting site for celebration, harkening back to the traditions of early Sedona. The annual Independence Day party was traditionally held at the Jordans' packing shed. Everyone dressed in Sunday best, arriving before noon. Packing tables were covered in white butcher paper with red and blue decorations and flags everywhere. Granny Jordan, Walter and George's mother, was famous for both her American flag and Lady Washington cakes. Fried chicken, potato salad, and homemade ice cream were other staples of the feast. Jordan in-laws from Tempe provided the fruit for lemonade.

George set off a blast of dynamite on the hill by the water tanks to signal the beginning of the celebration, and the feast was officially started when one of the men said a blessing. After lunch, revelers played croquet on the lawn and board games. Music was a highlight, with a variety of instruments and singers including George and his musical saw. Guests stayed after the feast, with the children and some adults swimming in the reservoir, which was warmer than most of Oak Creek. The day ended with guests replete and happy from the festivities.

Many are drawn from different places to this one in Arizona, where they care for both the land and their fellow people. The Sedona spirit is honored within these pages.

One

FIRST FAMILIES

A century before the word *diversity* meant what it does today, the future town of Sedona was an amalgam of heritages and customs. Jim Thompson was Irish, Henry Schuerman German, and Juan Armijo and Manuel Chavez Hispanic. What they shared were the qualities of independence, courage, and strength. After a vagabond youth, Jim Thompson settled in Oak Creek in 1876 as the first white settler. Arriving in 1879, Abraham James is credited with naming many geological features of the area. Frank Owenby came in 1893 and was the first to "prove up" on his homestead claim in 1901.

Manual Chavez traveled to Oak Creek in the late 1890s to take charge of a homestead claim for his son-in-law Juan Nuanez. An irrigation ditch had already been trenched out, and the two started raising cattle and vegetables. Chavez brought his son Ambrosio and his wife, Apolonia, to live with him in Oak Creek, where he filed a homestead claim in 1909. Today the family name lives on at Chavez Crossing near the Poco Diablo. The Chavezes stayed in the area into the 1920s, raising their orphaned relative Al Nuanez, who made a name as a wrangler, extra, and stuntman in movies.

Heinrich "Henry" Schuerman did not come to Oak Creek enticed by tales of grandeur in nature; he came to collect a debt. Born in Germany in the 1850s, Schuerman moved to the United States at 17. He left behind a girl named Dorette, who kept in touch through letters, and proposed to her by mail in 1884, upon which she immigrated to the United States as well. Schuerman moved to Prescott to help a cousin run the Pioneer Hotel and moved his wife to Oak Creek when land there was used as a payment to the hotel.

Steven and Martha Purtymun married in California in 1880 and followed the legendary Jessie "Bear" Howard to Oak Creek in 1887. Juan and Ambrosio Armijo, father and son, filed separate homestead claims on Oak Creek in the late 1800s. When Clara Thompson married Albert Purtymun in 1903, justice of the peace Juan Armijo performed the ceremony.

These early residents responded to the Homestead Act's invitation to own land in the West. Regardless of background or affluence, all shared the restless urge to find someplace new and better to create a life, and they built the town we know today.

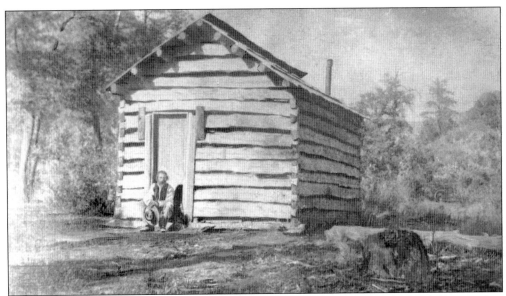

JIM THOMPSON'S FIRST CABIN, EARLY 1880s. When first arriving in Oak Creek Canyon, Jim Thompson claimed squatter's rights. Eventually, he filed for a homestead of 80 acres. When the land was finally surveyed, about 1900, he found that he had filed on a piece of land on top of Wilson Mountain. He had to relinquish his filings and file again on land where he was actually living.

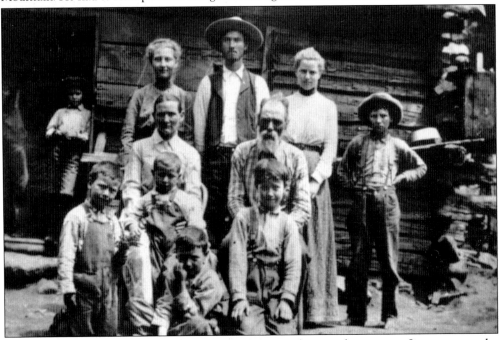

THE JIM AND MAGGIE THOMPSON FAMILY. After settling in the canyon, Jim wrote to the Abraham James family, who he had met at the Colorado River. Knowing they had a "marriage age" daughter, he invited them to leave Nevada and join him in Arizona. After the Jameses moved to the area, Jim wed Margaret, who was 22 years younger, in 1880. From left to right are (first row) Washington, Guy, Albert, and James; (second row) Maggie and Jim; (third row) Charles, Margaret, John, Clara, and Emery.

THE JIM THOMPSON CABIN. In 1912, Jim took another homestead of about 56 acres adjoining his original. As his children matured, he helped some of them homestead near him. His daughter Clara married before she proved up and was not allowed to take title, so she relinquished her rights to her brother Charles. Jim died in 1917 before he could prove up on his second homestead, but Maggie completed the claim.

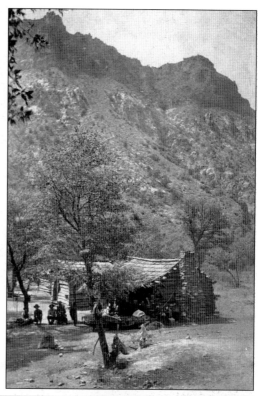

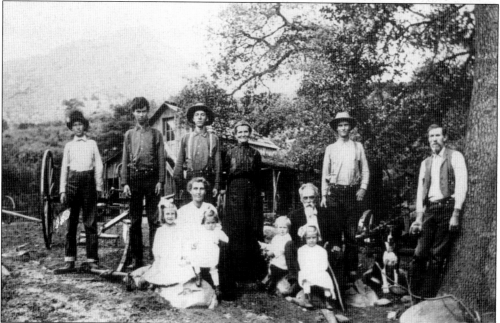

THE THOMPSONS WITH CHILDREN AND GRANDCHILDREN JUST BEFORE JIM'S DEATH. The Thompson family consisted of seven sons and two daughters. All nine of the siblings lived to adulthood, which was unusual in those days. The youngest child was six years old when Jim died, and Maggie was left to raise her large family alone.

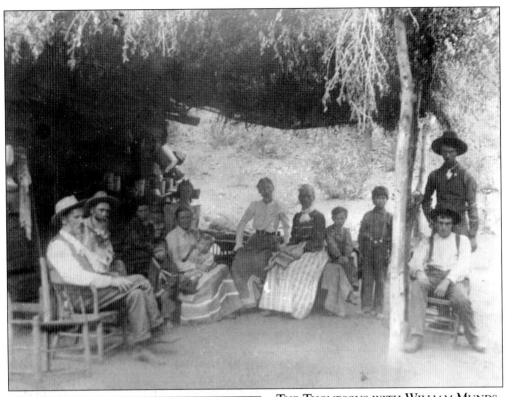

THE THOMPSONS WITH WILLIAM MUNDS. Neighbors were few and far between in the earliest days of settlement. The Munds family homesteaded in Spring Creek, and William (far left) moved his cattle to the mountain in the summer. This rare chance for these "neighbors" to be together was commemorated with a photograph.

LITTLE FRANK THOMPSON. Jim and Maggie's first child was a boy named John Franklin, born in 1882. Little Frank had the distinction of being the first white child born in Oak Creek Canyon. As an adult, Frank homesteaded on a dry farm in what is now known as Uptown Sedona, proving up in 1919.

THE ABRAHAM JAMES FAMILY. The Jameses were the first to settle in what would eventually become the city of Sedona. Land was not being surveyed yet, so they could only claim squatter's rights on the land they chose in 1879. From left to right are Lizzie, Margaret James Thompson, Abraham, Elizabeth, and Frank Thompson.

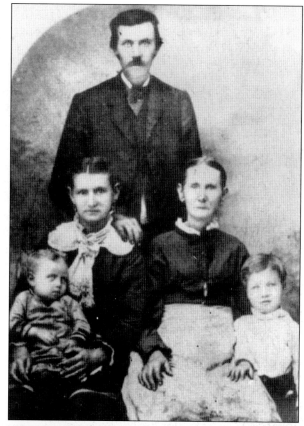

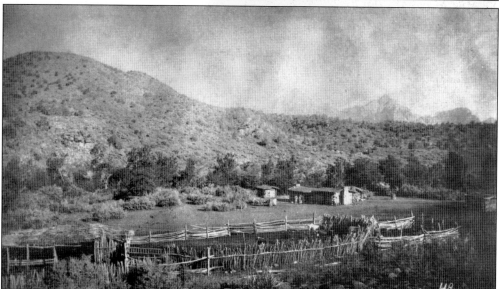

THE JAMES PLACE ALONG OAK CREEK. The James place was fairly level land along the creek, in the present-day Copper Cliffs area. Abraham built cabins, a corral, and a ditch, but he did not live to enjoy the property, dying in 1881. His widow and son lived there until 1895, when Elizabeth traded cattle for land farther down the creek, now the Crescent Moon Ranch.

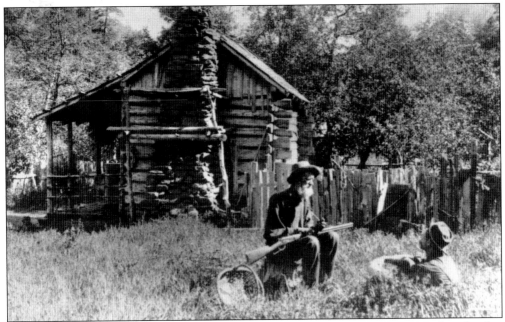

BEAR HOWARD'S CABIN. After breaking out of a California jail for shooting a sheepherder, Jessie "Bear" Howard came to Oak Creek Canyon. He lived near his daughter and son-in-law, the Steven Purtymuns, for years before being caught and sent back to jail. Howard was very elderly, and according to legend, his jailers let him escape to return to his home.

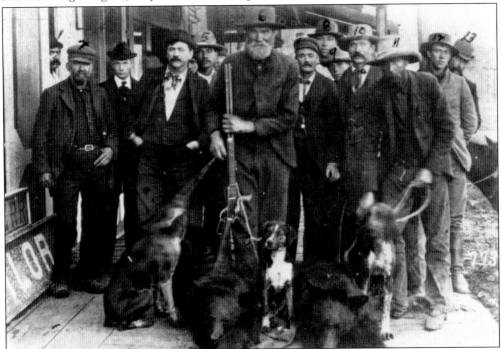

BEAR HOWARD. Howard (center) gained a reputation and made a living as an accomplished bear hunter, selling the bear meat to Flagstaff butcher shops. Also a trapper, he raised horses and mules. Widow Martha James married him briefly but apparently did not like being the wife of a trapper.

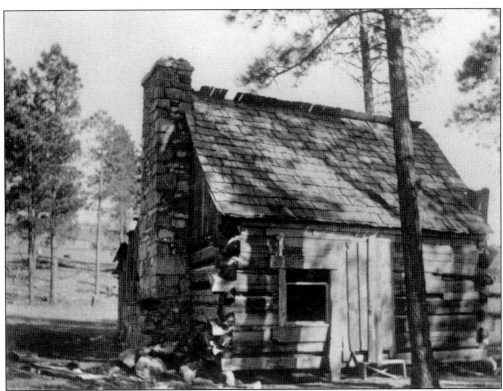

STEVEN PURTYMUN'S FIRST HOUSE.
Steven Purtymun worked at a logging
camp making and hauling railroad ties.
The first Purtymun house was located
on a timber claim homestead several
miles south of Flagstaff. After clearing
the land, Purtymun was able to farm
and raise a few cattle.

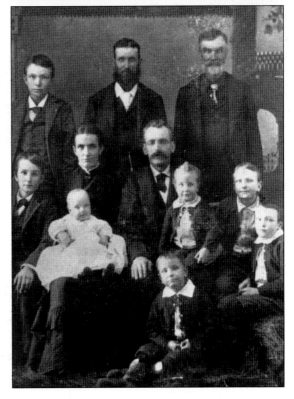

**THE PURTYMUN FAMILY WITH
GRANDPA BEAR HOWARD.** The
Purtymuns moved into Oak Creek
Canyon (today's Junipine) in the
early 1880s. Again they cleared the
land. They built a large log house
and an irrigation ditch and planted
a fruit orchard. In the early 1900s,
Steven and Martha divorced and he
moved away. Several of their children
stayed, marrying into other local
families and acquiring their own
property. From left to right are (on
the floor) Dan; (seated) Jess, Martha
holding Pearl, Steven, Charley,
Albert, and George; (standing)
Emory, Jesse J. Howard, and Bear.

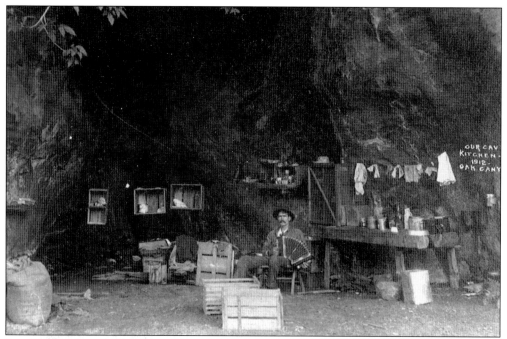

JESS PURTYMUN IN HIS CAVE KITCHEN. Early Oak Creek housing options were limited and primitive at best. A cave in the side of Oak Creek Canyon provided Jess, Steven and Martha's son, a place to live for a while. Other families lived in tents, tent houses, or log cabins.

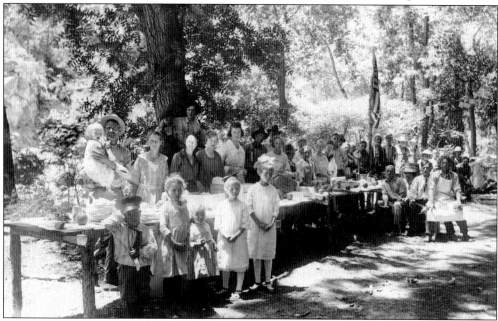

OAK CREEK FIRST FAMILIES AND FRIENDS PICNIC AT BANJO BILL SPRINGS. Picnics on the Fourth of July have long been a tradition for residents of Oak Creek Canyon. Times like these were for the scattered residents to get together and swap stories and socialize. For young people, picnics were a chance to meet each other—and maybe court. Thus many of Sedona's early families became related.

HEINRICH AND DORETTE SCHUERMAN. In 1884, the Schuermans came to Oak Creek to take possession of a 160-acre farm deeded to them in payment of a $500 debt. These "city folk" built an irrigation ditch, planted an orchard and a vineyard, and became successful in their new profession as vintners and orchardists.

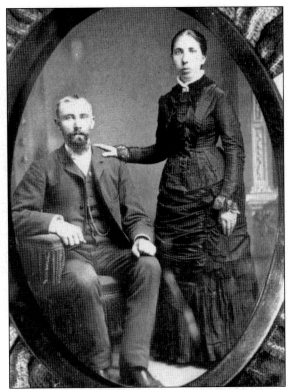

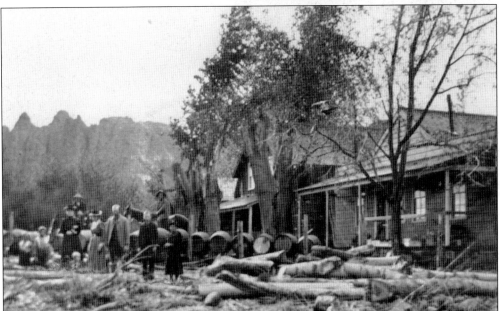

THE SCHUERMAN HOME. The Schuermans lived in a wood home that already stood on their new property when they arrived. Unfortunately, it burned down in 1900 along with all their possessions, except a few pieces of old furniture and a few things from Dorette's trousseau. To replace it, a strong rock house was built a quarter of a mile from the creek. Although fireproof, it washed away in a flood in 1920.

FRANK AND NANCY OWENBY. The Owenbys arrived from Texas in 1893 to homestead along the west side of Oak Creek, where the bridge crosses today. Their first filing was found to be in error so they had to refile. They were the first in Sedona to patent their homestead claim and receive title to their land. They built a difficult irrigation ditch that is still operational.

THE OWENBY FAMILY MOVING TO THE MOUNTAIN. After selling their first farm, the Owenbys homesteaded another 80 acres farther up the creek. The family also ran a considerable cattle operation until at least 1917. Here Nancy and Frank travel with their daughter Birdie and son Roy from their homestead to a summer range in the cool mountains.

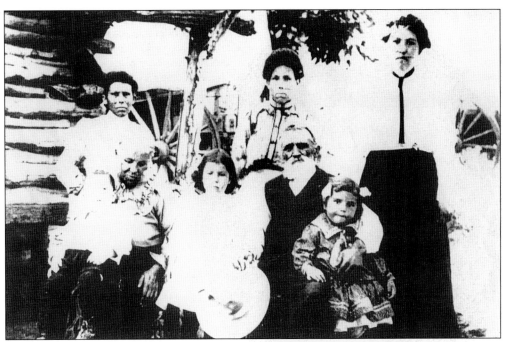

THE MANUEL CHAVEZ FAMILY.
When Juan Nuanez's American citizenship was questioned, he sent for his father-in-law, Manuel Chavez, to take the place he had been homesteading along Oak Creek. Chavez lost his rights to homestead again after he gave Nuanez's land back to him, but he traded an old wagon and a set of chain harnesses for land of his own. From left to right are (first row) Inezita holding Tom, Marcellina, Manuel, and Adeljada; (second row) Yaiea ? (a relative or friend), Victoria, and Salina.

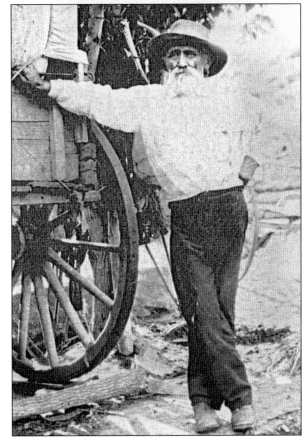

MANUEL CHAVEZ. Chavez was entitled to a pension from the federal government because of his service as a military scout for the army. When the government did not hold up its end of the arrangement, at age 70, Chavez rode alone on horseback from Sedona to St. Johns, Arizona, to fight for his payments. He hired a Spanish lawyer friend and won the case.

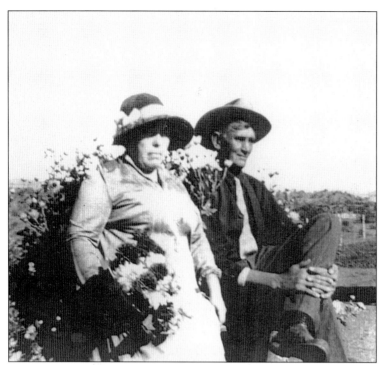

AMBROSIO AND MARCELLINA ARMIJO. Juan Armijo was a friend of the Chavez family who came to Oak Creek to homestead. Appointed a justice of the peace at the Red Rock precinct, he performed marriages, among other tasks. His son Ambrosio also homesteaded in Red Rock when he reached 21 years of age. The Chavez and Armijo families were forever connected when a Chavez daughter, Marcellina, married this Armijo son.

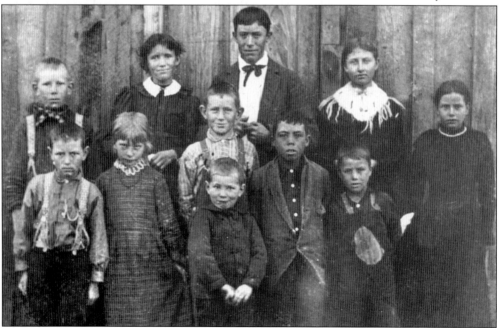

FIRST FAMILIES' CHILDREN AT SCHOOL, C. 1893. The area's first class of students at the first school represented the few families living up and down the creek. With its ethnic mix, it was not unlike a classroom today. Pictured here from left to right are the following: (first row) Henry Schuerman Jr.; (second row) Fred Thompson, Lena Schuerman, Nate Huckaby, Ambrosio Chavez, and Tom Chavez; (third row) Erwin Schuerman, Sarah Huckaby, Jim Huckaby, Lizzie Thompson, and Clara Thompson.

Two

THE SCHNEBLY FAMILY

If someone had told Sedona Arabella Miller that her name would live on after her, the little girl from Gorin, Missouri, probably would have thought he had taken leave of his senses. If you were born in 1877, being one of a dozen children meant doing your chores and putting up with a certain amount of sibling conflict. This was hardly a role that promised becoming the namesake to a town famous for its beauty.

Nevertheless, in 1901, Sedona's husband, T. C. Schnebly, bought 80 acres from early homesteader Frank Owenby and began building a two-story home. Along with their small son, Ellsworth, and baby Pearl, Sedona followed by train with their possessions. T. C. planted gardens and orchards and began selling produce north of Oak Creek Canyon in Flagstaff. He also brought tourists down to Oak Creek on return trips, which eventually led the family home to become a lodge and restaurant for early tourists.

T. C. applied to be the first postmaster in the area, and the town was named Sedona at his brother's suggestion in 1902. After the tragic death of Pearl in 1905, the Schneblys moved away and lived in Missouri and Colorado. They returned in 1929, became close friends of the Jordans, and ended up essentially working for Ruth and Walter—Sedona helping with the children and housekeeping, T. C. as a hired hand. Sedona did copious needlework in her spare time; her daughter Clara ruefully said she "crocheted around the edge of everything that didn't move."

Ruth Jordan recalled that the night before Sedona died, a huge thunderstorm drove everyone inside, and they were surprised to hear a knock at the door between booming echoes of thunder. There stood T. C., looking soaked and tired. He said Sedona had heard that Helen Jordan's father was ailing, and nothing would do but that she write him a get-well card for T. C. to deliver. Her last act was to think of someone else.

Lonely without his beloved wife, T. C. walked to town daily, becoming acquainted with visitors, suggesting side trips and hikes to honeymooners, and presenting women with pincushions he made of century plant stalk and autographed. T. C. died abruptly after a walk home from the post office and was buried next to his wife, where a marker proclaims, "He lives on in Schnebly Hill." He would ask no finer fate.

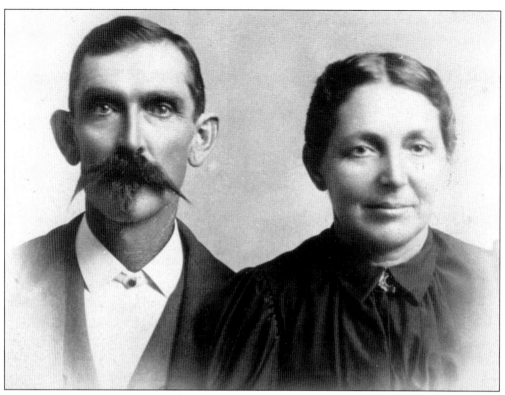

PHILLIP AND AMANDA MILLER. Sedona's parents were known as the second richest couple in their small town of Gorin, Missouri. Phillip owned a cucumber farm—a wise move in a town with a pickle factory—and Amanda raised 11 children.

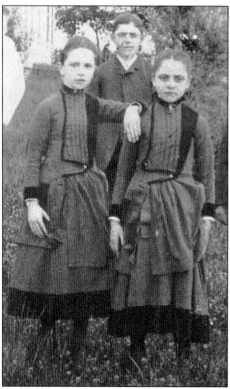

SEDONA IN GORIN, MISSOURI. Sedona (right) was known by townsfolk as "that little bug-eyed Donie Miller." The children, including her sister Lillie and brother Noah, were given simple diets, plenty of chores, and plainly decorated rooms to instill good values in spite of the family's relative prosperity.

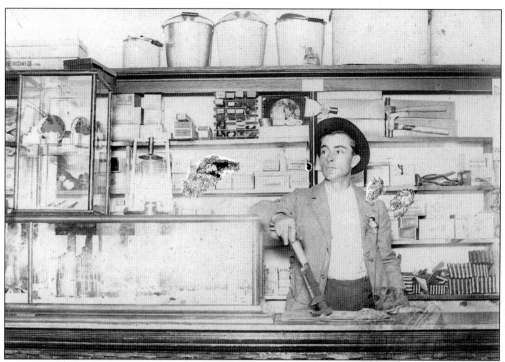

T. C. at Schneblys' Store.
Theodore Carl "T. C." Schnebly
was born in 1868 and lived in
Kahoka, Missouri, where he
completed high school. He and
three brothers chose Gorin,
Missouri, as a place to open a
hardware store in the 1880s.

Sedona Miller. Sedona was
the only one in her family with
an unusual name; her siblings
included Lillie, Edna, Minnie,
Noah, and Edward. Her mother
said simply, "I liked the sound
of it." It is possible that she had
heard the Creole name Sedonie,
used among free women of color
in the South.

LILLIE MILLER. When Sedona and her sister Lillie (shown here) were of courting age, Lillie attracted Loring Johnson, known for being suave and assured. Sedona attracted a man 10 years her senior who worked with his brothers. T. C. Schnebly did not seem like much of a prospect to local gossips. "Phillip Miller is getting 100 sons-in-law," they whispered before the daughters' weddings. "Loring is one—and Theodore Carl is double zeros."

THE YOUNG COUPLE. Sedona married T. C. Schnebly on her 20th birthday, February 24, 1897. Because T. C. was a Methodist and Sedona's parents were "predestination Presbyterians," she was written out of their will for joining her future to his, although that rift was later mended.

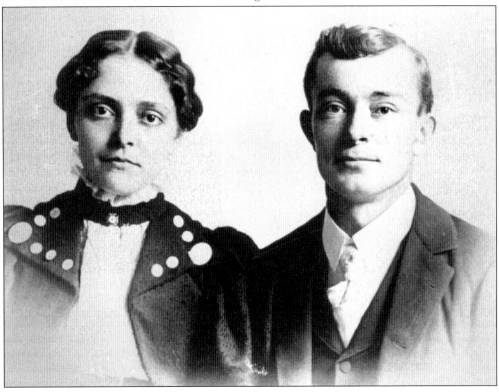

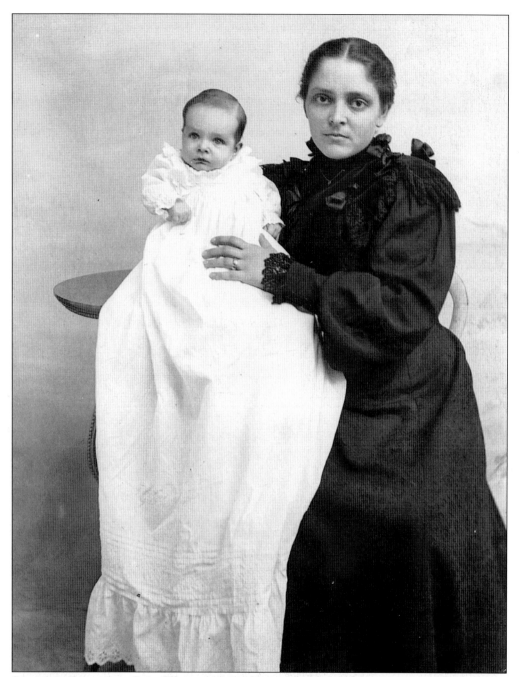

SEDONA'S FIRSTBORN SON. Ellsworth Schnebly was born in 1898. All his life, Ellsworth was devoted to his mother. Although he became a teacher and lived all over Arizona, he always came back to the town of Sedona to be near her. He corrected anyone who did not pronounce the town's name "See-dona," as his mother had.

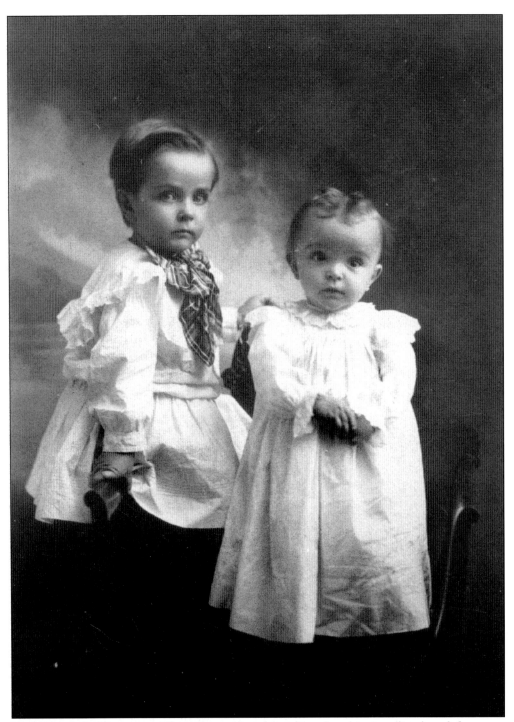

THE SCHNEBLY CHILDREN. Ellsworth was two years older than his sister Pearl, and they were constant companions. He took her with him everywhere, and as they grew older, they played house, bakery, and adventurer, amassing an extensive collection of arrowheads. The two were very close and adored one another.

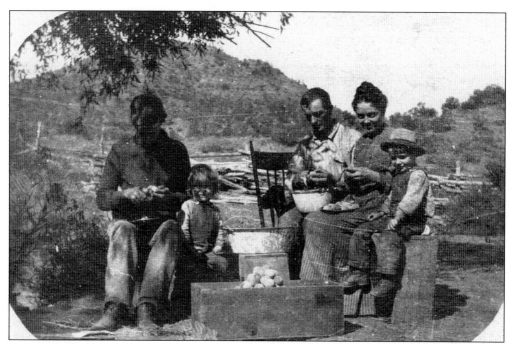

FAMILY OUTSIDE. A hired man peels apples with Pearl, T. C., Sedona, and Ellsworth around 1904. Sedona quickly learned that T. C. loved to spontaneously invite anyone he met home for lunch or dinner. "There weren't usually people up and around by breakfast," his daughter Margaret noted later, "or we would have had visitors then, too." And T. C. met a lot of people.

FAMILY AND HOUSE. When Sedona and T. C. first came to Oak Creek, only a handful of families resided there, but none close by. Missing her sisters, Sedona wrote long letters to friends back home, describing moving into their completed 12-room house and planting gardens and orchards. Genevieve, shown here in T. C.'s arms, joined the family in 1903, giving five-year-old Ellsworth and three-year-old Pearl a baby sister. The name of the family dog was not recorded.

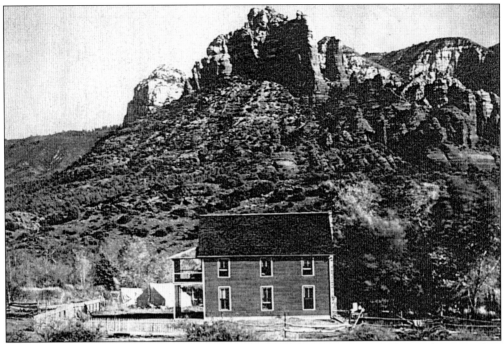

BED-AND-BREAKFAST. Because it was so large, the Schnebly house turned into the area's first bed-and-breakfast. Sedona became a famous cook; an account of one Thanksgiving dinner says 20 guests sat around a long table with a haunch of venison at one end, a roasted whole pig at the other, a large squash stuffed with cabbage, a turkey, and a goose!

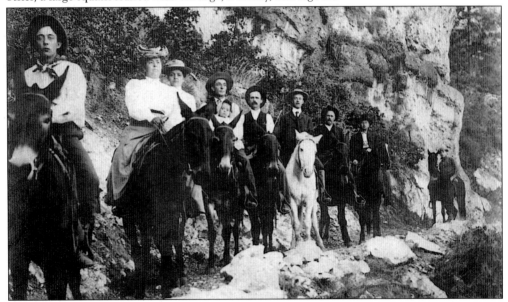

GRAND CANYON TRIP. In 1905, Sedona and T. C. took Sedona's sister Goldie to the Grand Canyon. Unfortunately, the Eastern woman blithely wasted most of their water. The travelers had to rely on springs, straining muddy water through an old piece of canvas. This photograph of the party was taken by the famous Kolb brothers. Sedona is third in line, with T. C. holding Genevieve behind her. It always held a place of honor on Sedona's dresser.

PEARL AND HER PONY. Pearl loved to ride. One day in 1905, rounding up cattle, she spied an arrowhead and tried to retrieve it. She tumbled off and was dragged back to the ranch by the frantic pony. Sedona, carrying baby Genevieve on the saddle, caught up, frantic and sobbing, while Ellsworth recalled picking up his sister's tiny shoe in the yard. Sedona cut a shroud for Pearl from her wedding dress.

PEARL'S GRAVE. Blaming herself for Pearl's death, Sedona asked T. C. to bury her four-year-old where she could see the grave from the kitchen window. At 28, she was already overworked, balancing paying guests, toddlers, and the rigors of frontier housekeeping. Sedona entered what would be described today as a severe depression, leading a visiting doctor to bluntly tell T. C. that he needed "to move her or lose her."

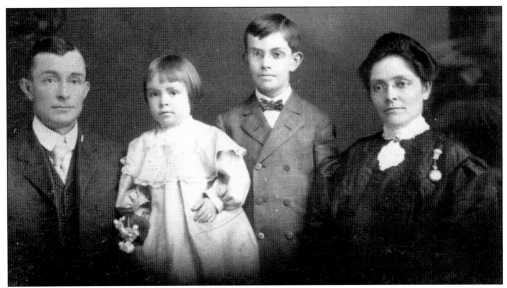

NEW, SMALLER FAMILY. T. C., Genevieve, Ellsworth, and Sedona were a smaller and more somber family when they moved to Colorado. Eventually, anthrax struck the herd of cattle, and a winter of burning carcasses sapped T. C.'s health. A childhood bout of malaria had left him with weak lungs and a lifelong distaste for coffee, which the doctors had given him with quinine.

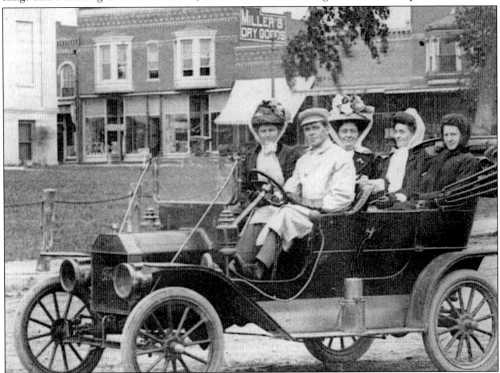

TEMPERANCE CONFERENCE–BOUND. Back East, the Miller women were involved in the Woman's Christian Temperance Union. This early photograph shows Sedona on her way to a temperance convention in Fort Madison, Iowa. Seated at left in the backseat, she wears a large flowered hat. She continued to deplore alcohol all her life.

SEDONA AND T. C.'S LAST HOUSE. Called "Mother Schnebly," Sedona could roll out pie crust while quizzing children on their Bible verses. She and T. C. lived in several small homes, each with the rock terraces, flagstone paths, and colorful gardens Sedona cultivated. This was their last home in Oak Creek. Sedona loved taking flowers from her garden to church.

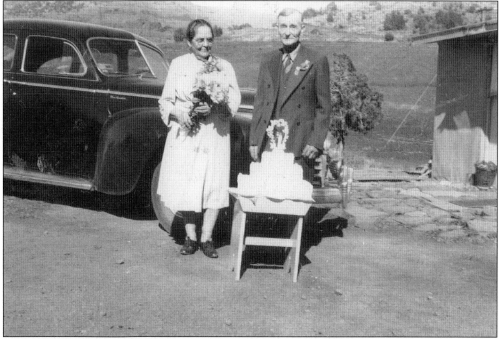

THE 50TH WEDDING ANNIVERSARY. When Sedona and T. C. celebrated their golden wedding anniversary, the entire town turned out to congratulate Mother and Father Schnebly. They brought gold-decorated gifts as thanks for the couple's endless hospitality and neighborliness.

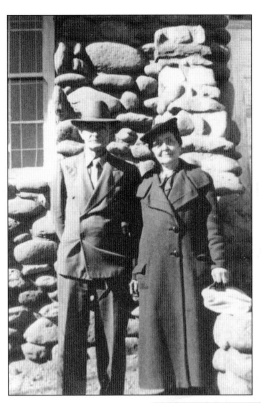

T. C. AND SEDONA ON SUNDAY. When Sedona died, T. C. did not want to memorialize her with flowers, which he said were of the earth, but with a bell, because it would peal through the heavens. A collection was taken for a bell for Wayside Chapel. "Dad loved to ring that for her," said his daughter Margaret. "And he always rang it on Mother's Day." That tradition continues today.

T. C. AT HIS DESK. T. C. spent hours handling correspondence and accounts. He loved spirited debate, discussions about Oak Creek, and hard work, though he wore neckties and pressed khaki pants religiously. Even in his 80s, he insisted on trekking up Schnebly Hill to select a sturdy branch of manzanita wood to use for his cane. He was a man who measured life in conversations more than money.

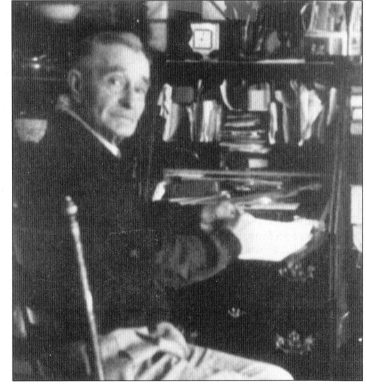

Three

FARMS AND ORCHARDS

Sedona's growth as a town has been possible since the beginning because of Oak Creek—a year-round source of water, rare in Arizona. When Jim Thompson first arrived at what he named Indian Gardens, crops had recently been abandoned, as the Apaches were taken to reservations. Thompson kept these vegetables growing, and the Pendleys grew various fruits in their orchards. The Schuerman family cultivated vegetables and fruits, including grapes from which they made wine.

Early growers the Jordans included George, who planted near the creek and dug irrigation ditches, and Walter, who settled on a dry farm. Walter worked with George, who had an engineering background, to create a hydraulic water pumping system. George also built a 20-foot waterwheel to irrigate some of his land, which not only worked long and well, but also became a favorite subject for photographers in the area. Walter's wife, Ruth, recalled that orchards were hard work. Winters meant heating the orchards with burners and smudge pots. One year, 600 peach trees yielded only 33 peaches. But the brothers eventually expanded to an operation of 1,500 trees. Peaches alone could yield 300 boxes a day. George's brother-in-law Bill Gray joked about how hard George worked. During tomato season one year, Gray and his wife, Alice, were staying with the family, and Gray said, "Sure don't take long to stay all night at the Jordans. About midnight Helen went to bed. At two, George came in, took off his pants, shook them, put them back on, and went to Flagstaff!"

During the Depression, area farmers cooperated rather than competed with one another. Again it was George Jordan who took on marketing all the produce, driving each week to Cottonwood, Jerome, and Prescott to the south and west, then to Flagstaff, Williams, Ash Fork, and as far as Winslow and Holbrook to the north and east.

A major part of what is now Uptown Sedona lies on the original Jordan land. George Jordan's old packing shed is now the Sedona Art Barn. Most of the commercial fruit growing ended in the 1970s, and local orchards began raising homes and commercial buildings. Ruth sold the final few acres of her beloved homestead to have it preserved forever as the Sedona Heritage Museum. The apple sorters, farm equipment, and tractor have retired, too, and are now enjoyed by tourists.

JOSEPH FARLEY FARMING. The Farleys homesteaded on Oak Creek along Schnebly Hill Road in 1908. A man named Eiberger had camped there and planted a garden but moved on before it had matured. Joe and his wife, Sarah Jane, used picks and shovels to build miles of irrigation ditches, a flume, and a dam. After patenting this homestead in 1915, Farley sold it and the family moved to the Texas oil fields.

THE DAVID DUMAS FARM. The Dumas family moved next door to the Schuermans in 1905. They grew peaches, apples, apricots, plums, and blackberries in addition to tending large gardens. David and Margaret Dumas were known throughout the valley for their warm hospitality, welcoming anyone who needed a bed or meal. Later their son M. O. Dumas would work the ranch and run cattle. The site is now known as Crescent Moon Ranch.

THE SCHUERMAN RED ROCK WINERY. Unfortunately, Henry Schuerman found out that the land the previous owners had occupied was not exactly what they owned due to a bad survey. Henry ended up buying some land from the railroad to straighten out the boundaries. He had settled here to improve the place and sell it to get his money back. Instead, he bought more land and the family prospered.

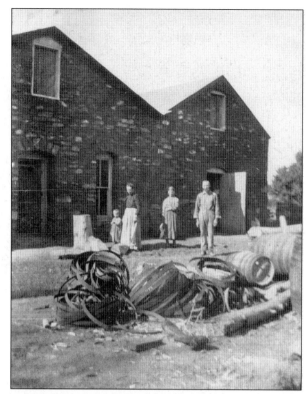

JEROME MINERS, AN EAGER MARKET FOR OAK CREEK FRUIT AND WINE. The Schuerman ranch stood at the base of Courthouse Rock (now Cathedral Rock). The family grew apples, peaches, apricots, and quince to name a few. They produced Zinfandel wine made in the style of their German ancestry. The Schuermans also made and marketed grape juice. Early Prohibition laws in Arizona marked the end of their wine business.

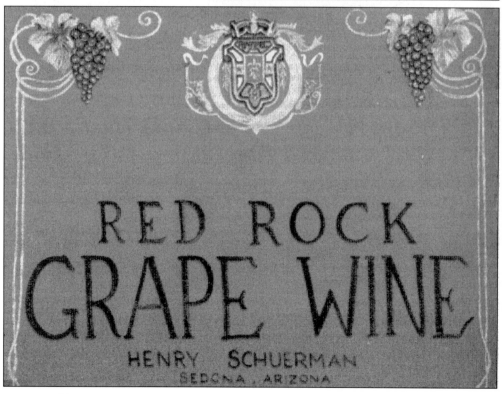

RED ROCK
GRAPE WINE
HENRY SCHUERMAN
SEDONA, ARIZONA

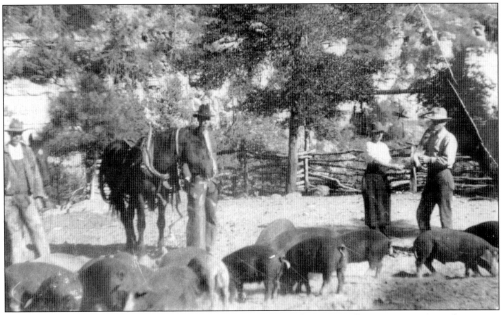

PENDLEY BARNYARD. The area's earliest settlers were subsistence farmers, meaning they grew what they needed for their own use. Frank Pendley arrived in 1907. He came to fish in Oak Creek and ended up returning to establish squatter's rights on a piece of land, filing for a homestead in 1910. In addition to gardens and orchards, Pendley raised cattle, hogs, chickens, horses, turkeys, rabbits, and mules for farming.

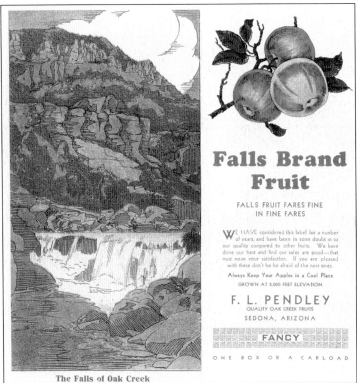

Falls Brand Fruit

FALLS FRUIT FARES FINE
IN FINE FARES

WE HAVE considered this label for a number of years, and have been in some doubt as to our quality compared to other fruits. We have done our best and find our sales are good---that must mean your satisfaction. If you are pleased with these don't be be afraid of the next ones.

Always Keep Your Apples in a Cool Place
GROWN AT 5,000 FEET ELEVATION

F. L. PENDLEY
QUALITY OAK CREEK FRUITS
SEDONA, ARIZONA

FANCY

ONE BOX OR A CARLOAD

The Falls of Oak Creek

PENDLEY FRUIT BOX LABEL. Frank Pendley built more than a mile of irrigation ditches that included sections of pipe and flume. The water moved through rock tunnels he blasted at a gradual angle, needed for gravity flow. He grew corn, squash, and alfalfa. He also developed a commercial orchard business of strawberries, blackberries, peaches, pears, apricots, walnuts, and apples. The Pendley site is now Slide Rock State Park.

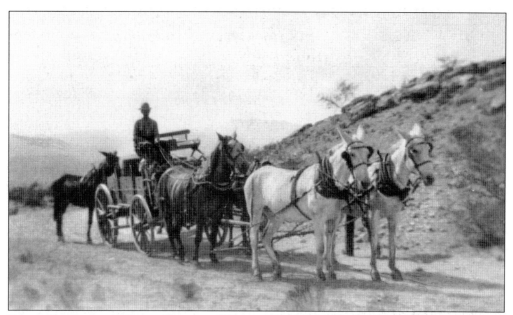

ERWIN SCHUERMAN TAKING FRUIT OR WINE TO MARKET, 1912. Hauling produce and wine to market was a difficult task for Oak Creek farmers and orchard keepers, as there was no railroad and only primitive roads for decades. A wagon and team would make the trip, sometimes taking one or two days, depending on if the market to be reached was in Jerome or Flagstaff.

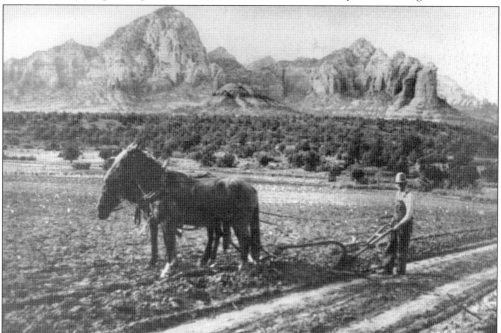

HENRY ELMER COOK FARMING. Cook's 1922 homestead extended from the base of Table Mountain and spread across 160 acres of Grasshopper Flat. His son Jay homesteaded another 160 acres nearby that would later become the Sedona West subdivision. When Henry and his wife, Effie, moved away in 1943, Jay built a motel, store, and gas station on part of the original homestead to meet the needs of the new motoring tourists.

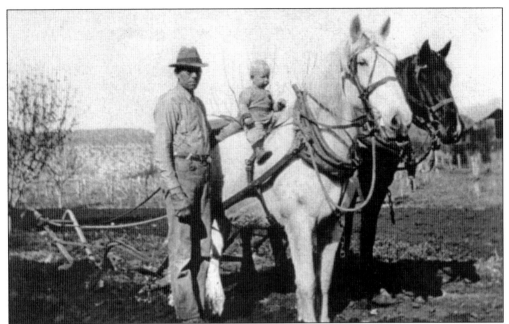

ERWIN AND FRED SCHUERMAN, C. 1928. Erwin was the Schuermans' eldest child. He homesteaded in 1908 and died in 1929. His widow, Mabel, married Albert Purtyman, and they stayed on the place until her son, Fred, reached the age of majority (21 years) and took over the farm. Fred developed a large commercial orchard business. The Pendleys', the Jordans', and Fred's orchards were probably the three largest in the area.

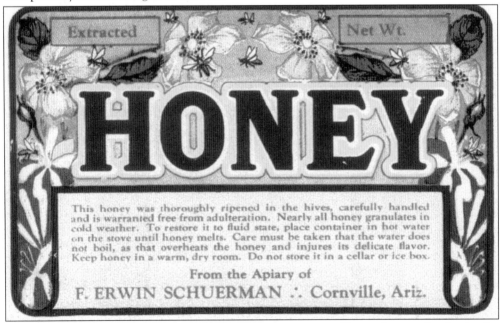

FRED SCHUERMAN'S HONEY LABEL. Bees are necessary to pollinate fruit orchards. As the orchards in the area grew larger, the owners began to bring in bee colonies to ensure enough to do the job. With the hives came the natural byproduct of honey, which then became another product for market.

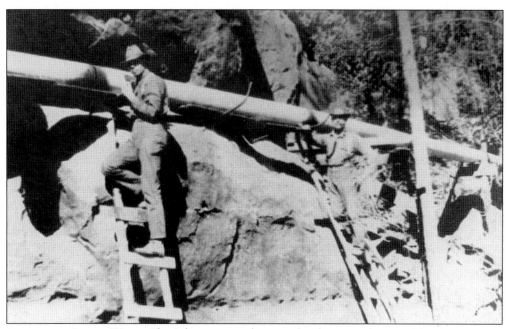

IRRIGATION DITCH WORK. The Schuerman and Dumas families were close neighbors and friends. They worked together to build and maintain an irrigation system. Henry and Dorette's son Erwin Schuerman (left) works here on part of the 1,500 feet of galvanized pipe in the system. The pipe was easily damaged by rock falls and was eventually discontinued.

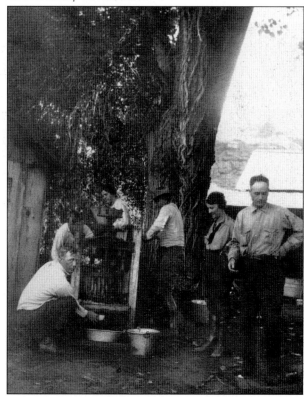

APPLE CIDER PARTY AT THE DUMAS PLACE. Cider presses were common at Oak Creek orchards. Apples were the most popular fruit for juicing, but the Dumas family also pressed blackberries. If the apple juice was allowed to ferment in a crock or barrel in a cool, dry place, it would become cider.

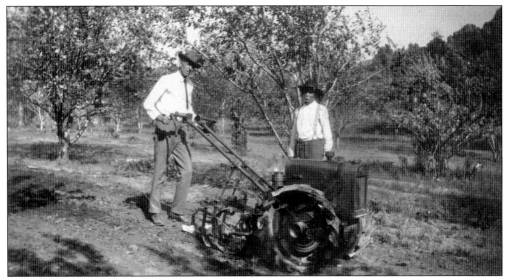

WILL STEELE AND JOE FARLEY TRYING OUT NEW EQUIPMENT. In 1924, Joe Farley (right) learned his old homestead was for sale, so he and Sarah moved back from Texas with their daughter Minnie and her husband, Will C. Steele (left). They split the purchased property, with the creek as the dividing line. The Steeles developed a good fruit and vegetable business that included growing mushrooms in a cave.

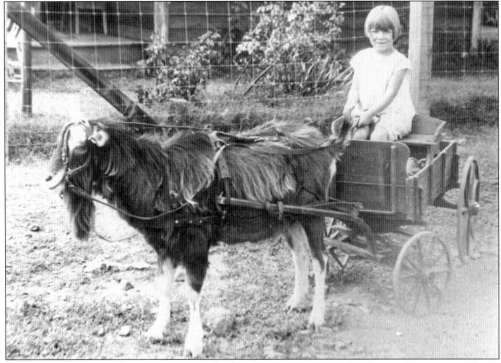

EDITH SMITH HARNESSING A FARM GOAT. Children were involved in the work and responsibilities of area homesteads. The Abraham Lincoln Smith family arrived in Sedona in 1915 to put their children in school. In this photograph, Abraham's granddaughter Edith Smith takes a spin in a farm cart with the help of a goat.

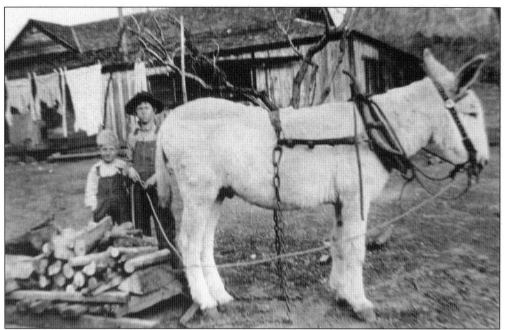

THE HART CHILDREN HAULING WOOD. L. E. "Dad" Hart and his family arrived about 1910 and bought land and cattle. Although Dad's store would be the first in Sedona to have electricity, that would not happen for another 25 years. So the Hart children gathered wood for the family cook stove. Open fires were used for laundry, soap making, and other household tasks.

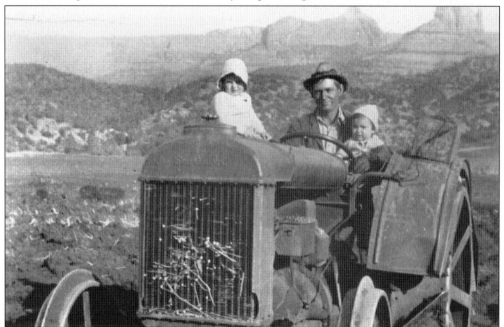

WALTER JORDAN AND DAUGHTERS ON A TRACTOR, C. 1937. The Jordan brothers were open to a modern approach to farming, something they learned from their father, Will. Will's successful lawsuit against the smelter in Clarkdale for damaging his crops helped purchase the ranches in Sedona, but Walter and George bought out Will's shares as soon as they could.

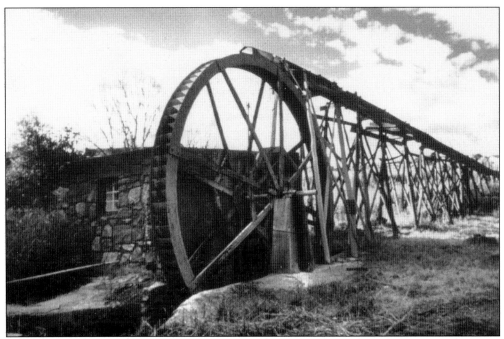

THE JORDAN WATERWHEEL, EARLY 1930S. The Jordan brothers each built irrigation systems. George's included this large waterwheel. Walter researched the design and George patterned the wheel after an image in a catalog. The overshot wheel—20 feet in diameter—was powered by ditch water. Walter ended up with a pumping operation that brought water to his farm.

ORCHARDS GROW TO COMMERCIAL SIZES. The Jordan orchards would eventually boast about 1,500 fruit trees. During World War II, Walter had a contract with the government to ship apples to troops. He made eight trips to Phoenix to deliver the order for 1,000 boxes, driving all night to meet the train and then driving all day to arrive back in Sedona in time to reload his truck.

HEINRICH SCHUERMAN VINEYARD, 1920s. Heinrich Schuerman planted extensive vineyards. After Arizona passed its own Prohibition law in 1915, Henry got into trouble by continuing to sell his wine; after all, winemaking was an honorable profession in his native Germany. An outpouring of community support resulted in a pardon from the governor. He briefly switched to making grape juice, but there was no market for it.

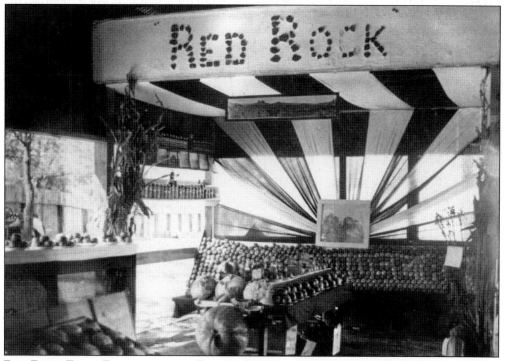

RED ROCK FRUIT DISPLAY AT THE COUNTY FAIR, C. 1930. Fruit from the Schuerman place, among others, was selected by fair organizers to make up this incredible display at the Yavapai County Fair. Note the photographs of Courthouse Rock (now Cathedral Rock). Red Rock fruit and vegetable growers were regular winners at the fair.

Jordan Carrot Crop. Before their fruit trees produced, the Jordans planted carrots between the rows of immature fruit trees. The harvested carrots were loaded on a Model A and, 12 hours later, were in Phoenix, where Ruth went directly to restaurants and hotels to sell. The Jordans later bought 55 acres for a "truck garden." The first year's bean harvest paid off the land.

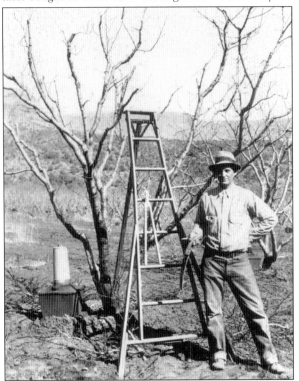

Walter Pruning in the Orchard. Orcharding required work in the field year-round. Pruning was one of Walter Jordan's specialties. When the pruning was done, other tasks had to be completed, such as spraying for pests, spreading fertilizer, monitoring the weather for moisture and killing frost, smudging, caring for equipment, and finally harvesting. Walter's three-legged ladder fit easily between the branches of a fruit tree.

SMUDGE POTS. Oak Creek orchardists used smudge pots to protect fruit from frost. The pots were brought to the field on a sled. At Walter Jordan's place, the sled was pulled by a Caterpillar tractor. Once the pots were placed, the dampers were opened and cleaned and then each pot was topped off with diesel fuel. When the signal was given, workers raced through the trees with a torch.

MECHANIZED APPLE-SORTING MACHINE. The apple-sorting machine in Walter's fruit-packing shed was state-of-the-art in 1948. It was not uncommon for it to run eight hours per day during the harvest, stopping only for the packers to catch up when their bins became full. At one time, the Jordans were the largest private employer in town, employing locals for mostly seasonal work.

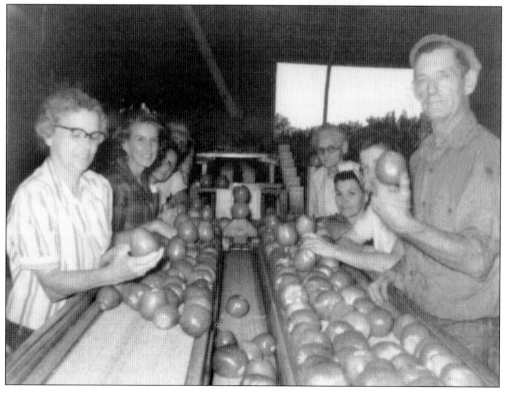

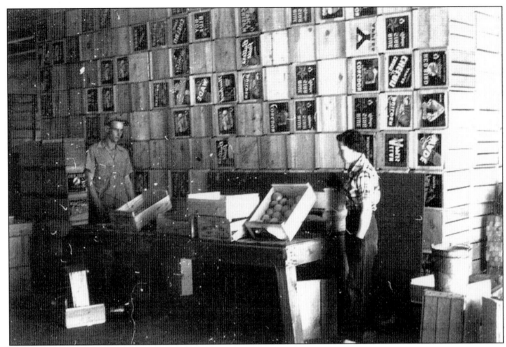

FRUIT BOXES STACKED TO THE PACKING SHED ROOF. The smooth concrete floor of Walter Jordan's new packing shed was popular with local kids for roller skating. How disappointed they were when harvest time arrived and their skating rink was filled with boxes and workers!

THE WALTER JORDAN PLACE. Many orchards are still visible in photographs, especially aerial views, of Sedona in the 1970s. But the influx of retirees in that decade brought a transition from an agriculture-based economy to one of development and tourism. Walter and Ruth Jordan began to sell off their orchard. Ruth worked to preserve the final four acres as Jordan Historical Park.

Four

RANCHING AND RANGE

The word *cowboy* conjures an image of a relaxed and loose-jointed, sun-browned man guiding a horse with his knees into cow camp. This image is untrue for most ranchers, who would be the first to say ranching is less romance than hard work.

Frank Owenby, who owned several pieces of property in early Sedona, was known for his phonetic cattle brand, ONB. Early ranchers moved their cattle from season to season. William Munds developed the Munds Trail, which was later further refined into Schnebly Hill Road. During the summer, the cattle grazed above the Mogollon Rim. During the winter, they were driven down to the Verde Valley.

Ranchers stuck together. When one needed to round up the herds to drive them from summer to winter pasture, everyone else pitched in. When it came time for a roundup, M. O. Dumas recalled, the men would meet and elect a wagon boss, who made arrangements for a chuck wagon and provisions. Each cowboy provided his own bedroll, he said; the covers were called sugins, the pillows called goose hair. A cowboy working for an Oak Creek outfit made about $30 a month. Breaking a wild horse fetched a $5 bonus. Dumas also said Brin's Mesa was named for an old maverick brindle bull that ranged there uncaptured despite the best efforts of many wranglers over the years.

Early resident Fred Croxen wrote that it could take a remuda of 75 or more horses to run a roundup, and that hobbling the horses at night was a big job that had to be undone every morning.

Allen Bristow, a cousin of the Jordans, recalled in his memoir *From Trail Dust to Jet Trails* that his cowboy father married his schoolteacher mother and he grew up immersed in ranching life. He fondly described watching others ride wild horses, being thrown off a stubborn burro, and learning to rope horses by chasing them until they were so tired he could lay the rope on the ground and they would walk into it.

Few ranchers owned their grazing land. The Forest Service issued grazing permits to most of them. The Sedona Allotment was the largest, including most of today's city.

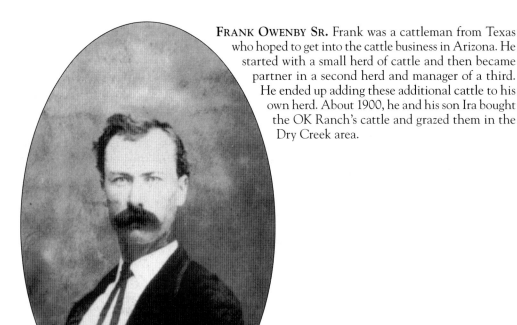

FRANK OWENBY SR. Frank was a cattleman from Texas who hoped to get into the cattle business in Arizona. He started with a small herd of cattle and then became partner in a second herd and manager of a third. He ended up adding these additional cattle to his own herd. About 1900, he and his son Ira bought the OK Ranch's cattle and grazed them in the Dry Creek area.

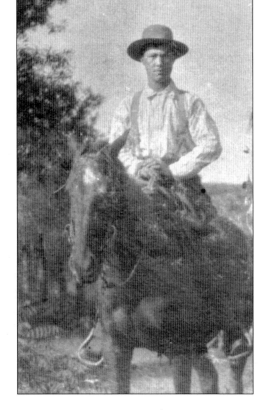

ROY OWENBY. Roy Owenby, son of Frank and Nancy, started punching cattle about as soon as he was able to sit on a horse by himself. By the time he was 12, he was a top hand. He ran his parents' Red Rock ranch for a short time and then set off to build his own herd. In the 1930s, he and his wife, Lena Schuerman, inherited part of her father Henry's place.

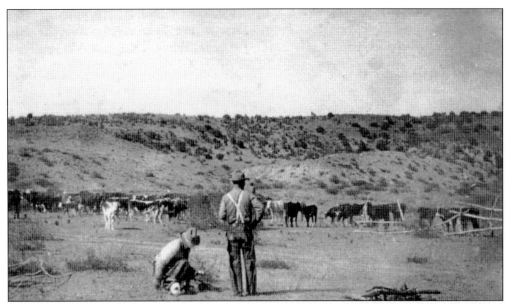

ROY OWENBY RANCHING ON THE SCHUERMAN PLACE. In 1910, Roy Owenby married Lena Schuerman. For the next 20 years or so, the couple moved around while Roy homesteaded, worked for wages, and assisted at the Clemenceau smelter near Jerome. After the smelter closed in the late 1930s, he moved back to Red Rock to run part of the Schuerman ranch his wife had inherited at about that time.

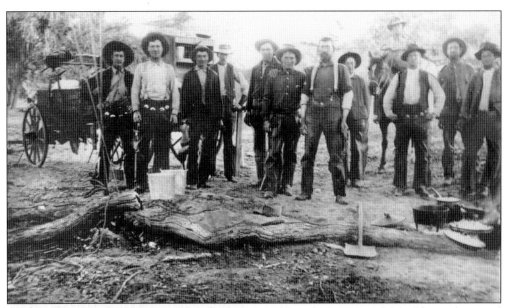

OAK CREEK ROUNDUP, 1909. In the early days of ranching, there were no fences; the stock roamed and mixed for miles around. Roundups brought the herds back together so they could be moved between Verde Valley winter range and summer range on the cool mountain. This roundup crew at camp includes members of the Owenby, Dickinson, and Lay families, among others.

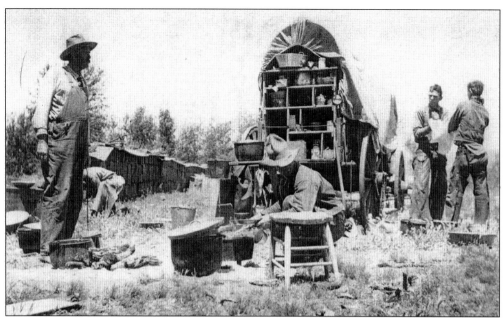

OAK CREEK ROUNDUP CHUCK WAGON, 1912. A good camp cook was an important member of any cattle drive. The cook worked from a chuck wagon outfitted with a drop-leaf table. When secured upright, the table protected nooks and bins holding food staples. Water bags, Dutch ovens, large pots, pans, and a coffee pot were standard equipment. Cooking supplies, bed rolls, and other equipment were carried inside the wagon.

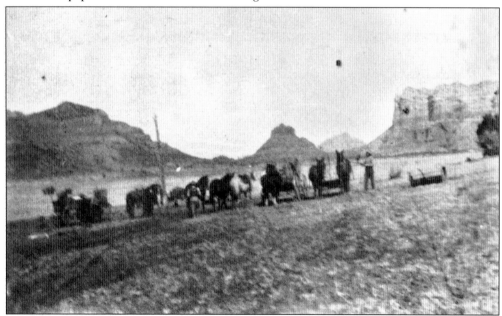

BUILDING A WATER TANK IN BIG PARK, C. 1910S. Big Park was a popular roundup location, but there was no water for the herds. Local ranchers worked together to build "tanks," depressions in the ground that caught and held natural runoff from gullies. Using teams, they employed "fresnos" or slip scrapers, dragging the equipment over the hard ground until the tank was deep enough. These same fresnos were used to build roads.

COWBOYS RIDING BRONCS. During the summer on the high country range, cowboys entertained themselves and others with informal rodeos. The crowd passed a hat, collecting prize money. A working cowboy applied his skills in hopes of winning a little extra cash. Working cowboys who "rode the rough string" rode the youngest, least-trained, and least-experienced (or "spoiled") horses in a herd. Some of that experience no doubt paid off at a rodeo.

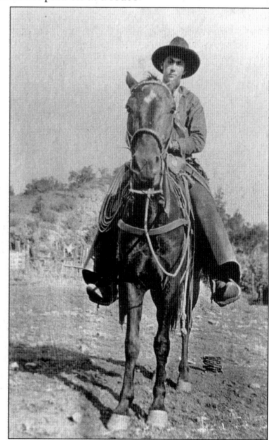

IRA SMITH ON THE BLACK PLACE, C. 1920. Ira worked for several local cattle outfits and was well-known as a horse trainer. When not working as a cowboy or for the movies, he helped good friend Earl Van Deren round up wild cattle and brand them. A stack of horseshoes on the ground hints that Ira took a break from shoeing horses for the Blacks to pose for this photograph.

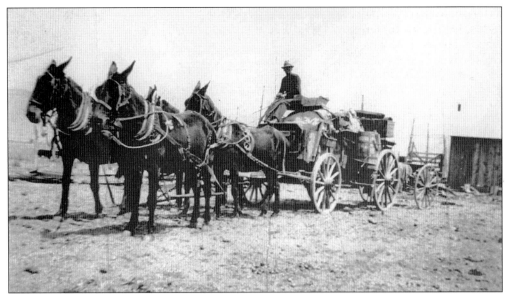

WINDMILL RANCH CHUCK WAGON. Many large cattle outfits like the Windmill operated in the Verde Valley. While the Windmill's herd took a trail north of Sedona, their chuck wagon drove the road through Oak Creek Canyon. The timing of a roundup depended on the condition of the range as to feed. An elected wagon boss would hire a cook and a horse wrangler, as well as buy provisions and other necessities.

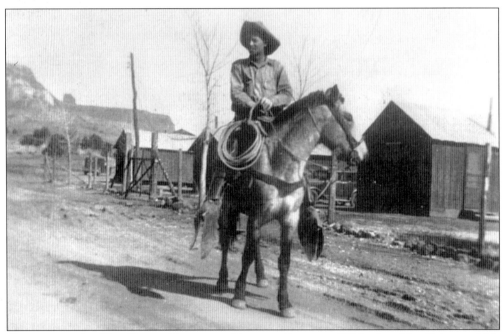

COWBOY AT THE VAN DEREN RANCH IN UPTOWN SEDONA, 1930S. Lee Van Deren and his family arrived in Sedona from Clay Park about 1911. They operated a fruit orchard and large garden, but Lee also bought the ONB and FO cattle. When Lee became ill in 1924, his son Earl negotiated with the bank to take his father's herd and pay off the outstanding loan.

54

KEL FOX ON OLD BARNEY, 1930S. Kel Fox saw his future in ranching on his family's Foxboro Ranch, arriving during the difficult decade of the Depression. Despite his Ivy League degree, he was devoted to ranching. Later becoming a state legislator, Kel was instrumental in building Arizona's groundwater management policy in its early days.

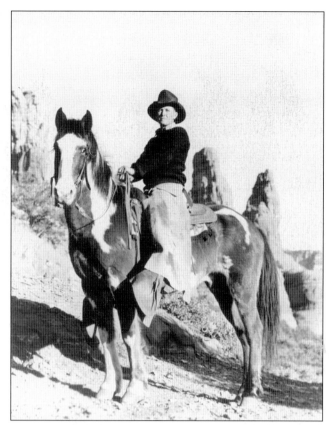

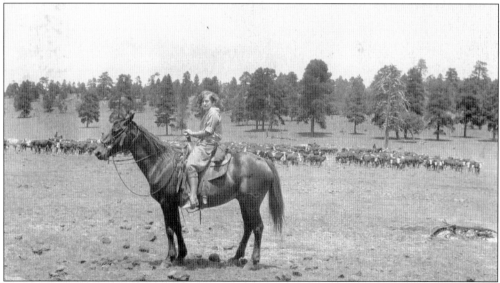

WOMEN AND RANCHING. In the 1800s, women weren't allowed to ride in cattle drives. However, in the 1900s, it was fairly common for Verde Valley women to be seen riding astride their horses (versus sidesaddle) and working as an extra hand for routine family cattle work. Sedona women worked checking water holes, checking the general health of the herd, and driving cattle to new water tanks or salt grounds.

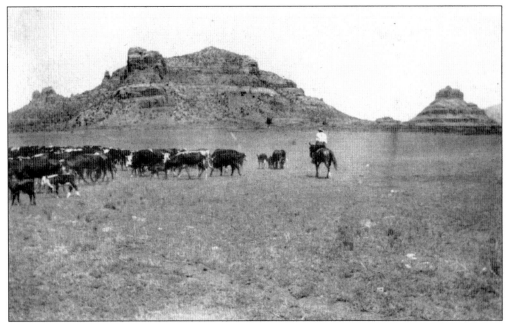

Myron "Budge" Loy Working Cattle, 1910s–1920s. The Samuel Loy family arrived in the Verde Valley in 1876. Samuel's grandson Myron Loy cowboyed before going off to World War I. His army pay book stated his occupation as "cowpuncher." After the war, his free cowboying days wrapped up when he married Frieda Schuerman and they worked for her family. Eventually they inherited a piece of Schuerman land.

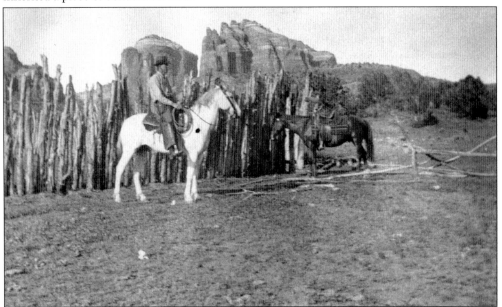

Fritz Schuerman, c. 1915. After serving in the army in World War II, another Schuerman son, Fritz, returned to work on the family place. A longtime cowhand, he eventually opened one of the first real estate offices in Sedona. Like his siblings, he inherited part of the family farm (today's Red Rock State Park). The picket corral in this photograph was typical of those built by ranchers as holding pens where they held their biannual roundups.

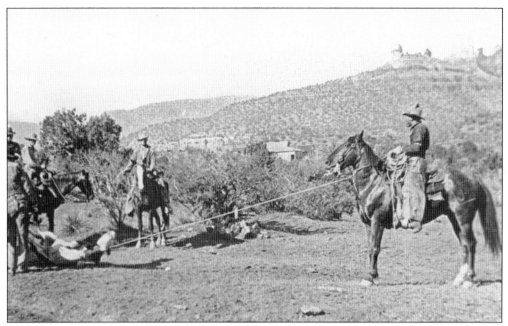

COWBOYS IN TOWN. Sedona really wasn't a town nor did it have many residents until the 1950s. This was fine with area ranchers, who drove their cattle right on the roads on their way between summer and winter ranges. There were several natural gathering places where cattle were herded and calves were allowed to "mother up" with their mamas. Ownership was established, and the calves were branded to match the cows' brands.

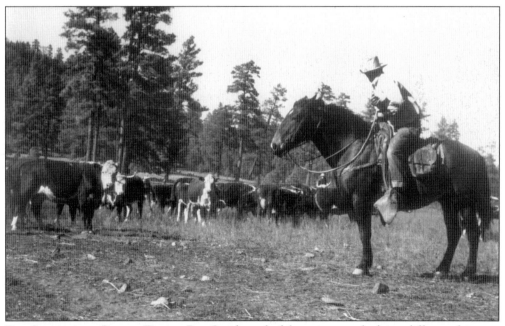

ROE SMITH ON A CATTLE DRIVE. Roe Smith worked for many people doing different things to make a living. Working cattle was just one of his jobs. After Roe returned from World War II, he worked for the U.S. Forest Service. Around that time, people started putting up fences around parts of town to keep cattle away from cars, gardens, and orchards.

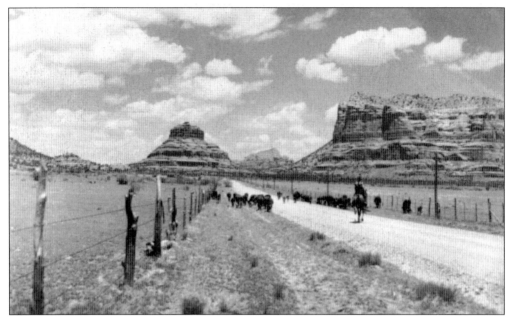

BIG PARK, 1940s. Years ago, Big Park had little settlement because rainfall was its sole source of water. Dry farming coexisted with the occasional cattle drive. Big Park, Woods Canyon, and the House Mountain area were the lower section of Kel Fox's grazing allotment, used for his winter range. (Courtesy Bob Bradshaw.)

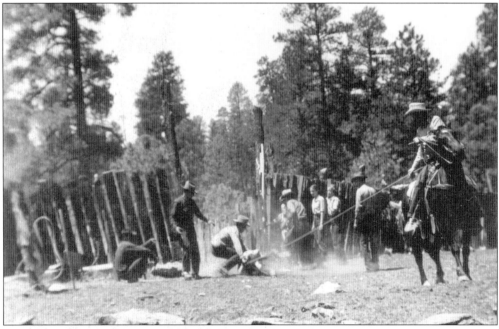

KELLY SEEP ROUNDUP, 1948. Kelly Seep was the summer headquarters for Otto Hallermund's herd. A spring seeping from the ground provided water and gave the area its name. Otto arrived in Flagstaff in 1925 and bought land near Sedona in 1938. His grazing permit stretched from Grasshopper Flat and Little Horse Park in the winter to Mexican Pocket and Kelly Seep in summer. When he divorced, Otto had to split the allotment.

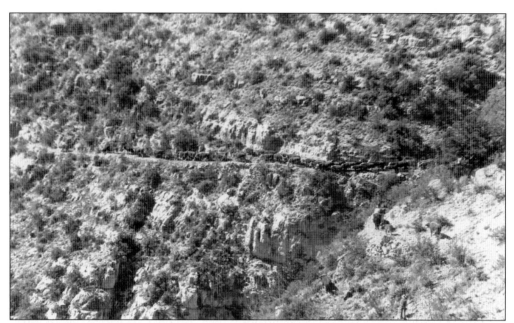

NARROW CANYON CATTLE TRAILS. Both Munds and Casner Trails hang on canyon cliffs and lead from the east side of Oak Creek in Sedona to the Mogollon Rim. Both were roughed out in the 1890s. These trails were followed by their namesakes and others when moving cattle from Verde Valley ranches to mountain ranges. They continued to be used until the end of Sedona's ranching days.

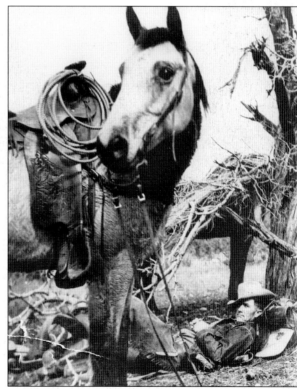

COWBOY ON A BREAK ON THE WINDMILL RANCH, 1970s. Ira Smith and his horse Buck enjoy a much-deserved break. The need for cowboy work was based on the existence of the open range and required men to round up, move, and care for cattle within that unshackled concept. Arizona still has open-range laws on the books.

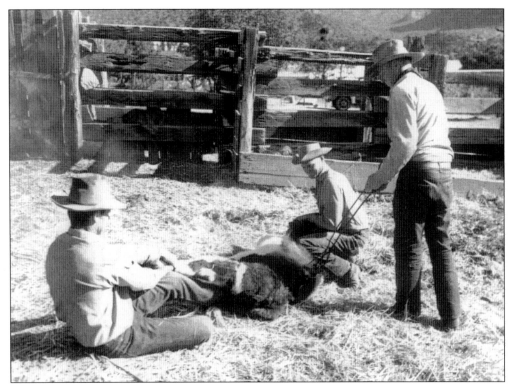

SEDONA-AREA RANCHERS BRANDING. Earl Van Deren entered the ranching business at the age of 15, when he had saved enough money to purchase land with his father in what is now Uptown Sedona. As more people started to move to the area, Earl could see that the place would soon be better for people than for cattle, and so the family moved away in the 1950s.

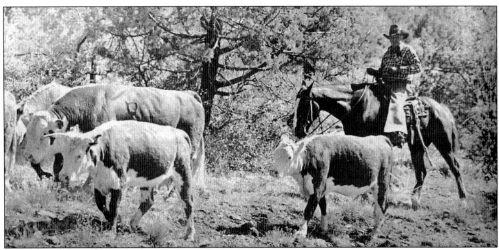

PETE MICHELBACH DRIVING HIS CATTLE. Pete Michelbach was the last rancher to hold a U.S. Forest Service grazing permit in what are now the Sedona city limits. He bought part of Otto Hallermund's permit and some land in 1951, fulfilling a longtime dream of ranching in Sedona. As the town grew, newcomers cut Pete's fences and drained his water tanks. He held his permit and ran cows until he passed away in 1997.

Five

ROUTES AND ROADS

In the 1990s, Rand McNally proclaimed the route from Flagstaff to Sedona, State Route 89A, "one of the most scenic roads in the nation." While driving the 3,000-foot descent from ponderosa pine to juniper and oak, one will see the gorgeous scenery but also understand how difficult it was to build that road.

Jim Thompson exited Oak Creek in the 1880s by following a route to Oak Creek Canyon's rim that eventually became known as Thompson's Ladder. When his roads from Indian Gardens to Sedona washed out, he put one over the mountain by Steamboat Rock and down modern-day Jordan Road. It was not until 1906 that canyon resident Louis Thomas got a rough trail laid out from Flagstaff to around West Fork; from there, the last leg to Sedona had to be traversed on horseback.

In 1907, Albert Purtymun built two miles of road, joining his place at what is now Junipine Resort with Thomas's stretch. And in 1913, he convinced the Coconino County Board of Supervisors to fund a work crew and materials to complete what is now 89A. Thompson recalled that the original road made 16 crossings of Oak Creek. In 1922, the county began replacing this early effort with a highway down the switchbacks. The stretch from Indian Gardens was constructed at various times and included a tunnel. Midgely Bridge was completed at the north entry to Sedona in 1939.

While most people drive into Sedona on either 89A from the north or State Highway 179 from the south, another way is the still-unpaved Schnebly Hill Road. After John Loy had roughed out much of the route beginning in 1896, some local men put up funds that were matched by the board of supervisors. (Family records show a letter from George Babbitt to T. C. Schnebly regarding this government action.) The crew worked with wide, curved metal tools called Mormon scrapers after the Mormon towns laid out with streets wide enough for a team and wagon to turn around. The crew also used dynamite for areas too rugged to level by hand. Because the terminus of the road was the Schnebly home, which doubled as a general store, the new route became known as Schnebly Hill Road.

The state finally decided to build a road from Sedona to the new Black Canyon Highway, Route 179, which was completed in 1961.

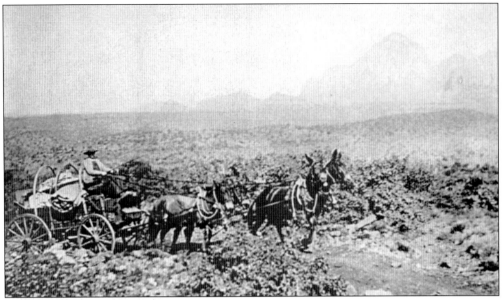

OWENBY FREIGHT WAGON, GRASSHOPPER FLAT, C. 1890S. Early transportation options into Sedona were few and primitive. The Beaver Head stage station (south of Big Park) existed briefly from 1876 to 1882. Jim Thompson told stories of using ropes to stabilize his wagon while crossing Dry Creek. Those arriving at Jerome Junction by train could hire wagons to bring them to Sedona. Having teams and wagons, the Owenbys ran freight for extra cash.

BUILDING SCHNEBLY HILL ROAD. John Loy began the Verde Cut-off Road prior to 1901. Much of the work was done by hand, including drilling the big rocks for dynamite. This road provided a major improvement and saved days of travel time to Flagstaff. Because T. C. Schnebly worked on its construction and it led to his home, the route was named Schnebly Hill Road.

OLD CANYON ROAD. When settlers traveled to Flagstaff from upper Oak Creek Canyon, they loaded their horses with supplies and walked them to the top of the rim, where they left their wagons. The county promised settlers that if they built a trail through the canyon that could accommodate an empty wagon, then the county would maintain that road.

NEW OAK CREEK BRIDGE UNDER CONSTRUCTION, 1916. Oak Creek divides the town of Sedona, and so a safe and easy crossing point has been a struggle since the earliest days of settlement. Originally the crossing was above the location of today's Oak Creek bridge. It is unclear if there was any kind of span at this location prior to the 1916 construction of an iron bridge.

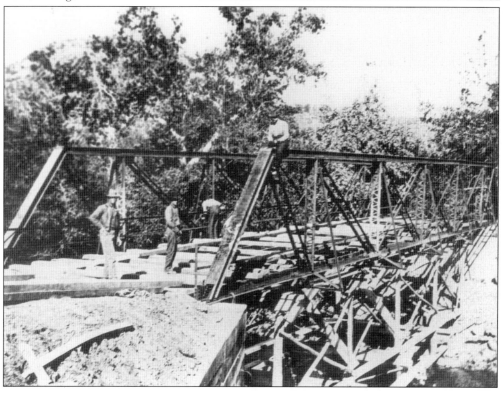

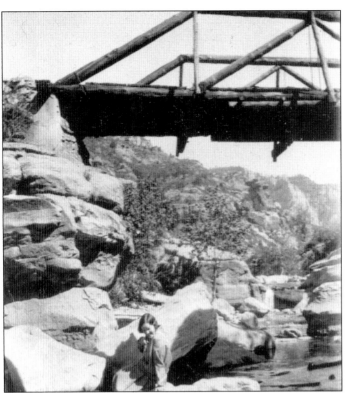

OLD SLIDE ROCK BRIDGE. In 1914, Jess Purtymun was building a road north in Oak Creek Canyon and Frank Pendley was building south. The two crews worked toward each other until they met at Oak Creek Falls and built a wooden bridge. In July of that year, the first road opened connecting Flagstaff with the Verde Valley.

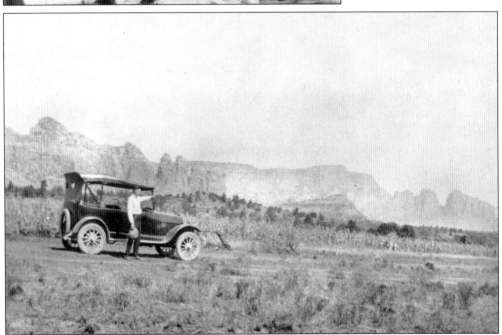

THE ROAD THROUGH GRASSHOPPER FLAT, 1922. Not until the early 1920s did Yavapai County build a graded but unpaved road from Cottonwood to the county line west of Sedona. Some of the first settlers at Red Rock had a "bear slide" road down the steep hillside from Grasshopper Flat to the trail from Sedona to Cottonwood.

OAK CREEK CANYON TUNNEL. The original road up the canyon connected bits and pieces of trails leading from one homestead to another. In 1922, Coconino County started a road wide enough for two cars. As part of a road construction contract in the late 1920s and early 1930s, this tunnel was removed.

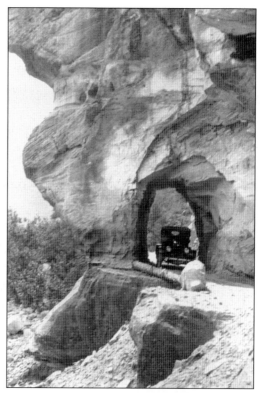

OLD CANYON ROAD, 1930S–1940S. Improvements to the canyon road continued on a somewhat regular basis. Contracts were let for section after section, even during the Depression decade of the 1930s, providing much-needed employment for local men. Improvements ceased during the shortages of men and materials created by World War II. It was during this time that the road's name was changed from State Route 79 to U.S. 89 Alternate.

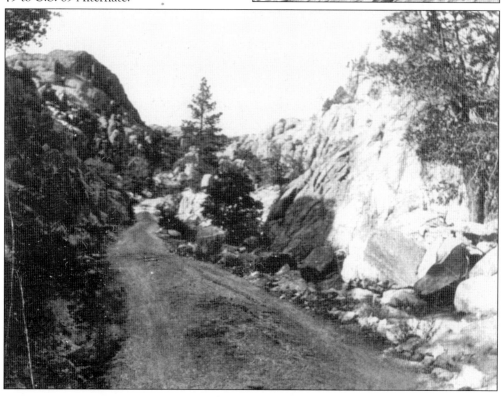

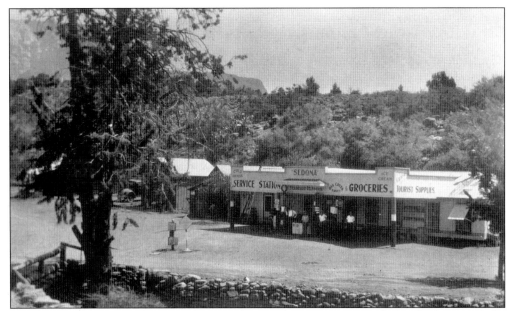

THE HART STORE, ESTABLISHED 1926. When Dad Hart came to Oak Creek about 1913, he bought cattle and land. In 1926, he built a modern country store, the town's first, on the main road through Sedona. At first, the little general store dispensed gasoline from barrels, but soon Hart installed pumps.

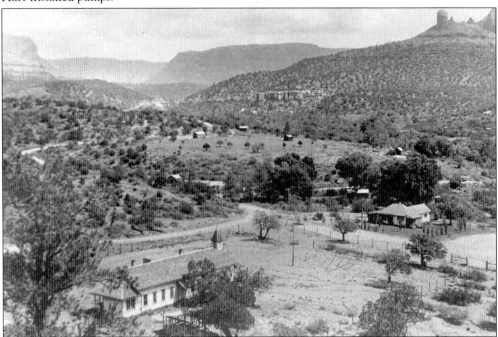

THE ORIGINAL HEART OF SEDONA, 1930S. The main roads into Sedona were not much more than trails at first. Schnebly Hill Road and the road from the south came into town on the east side of the creek, crossed, then proceeded along present-day Ranger Road, crawling the hillsides to Grasshopper Flat. Sedona's first commercial district grew up along this road. The Hart Store is in the center of the photograph, and Sedona School is in the foreground.

THE STEELE FAMILY TRUCK ON THE OAK CREEK BRIDGE, 1930s. Road improvements and the spread of the automobile made Oak Creek fruits and vegetables easier to get to market. This bridge was replaced in 1948.

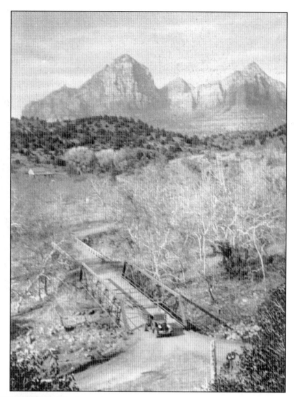

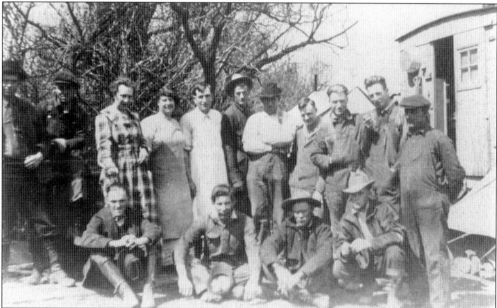

OAK CREEK CANYON ROAD CAMP, 1930s. The canyon road was built and rebuilt several times because of floods, washouts, and improvements. Steven Purtymun's sons were all roadbuilders at different times. Albert worked on a road at the north end of the canyon. Jess was instrumental in many road projects from about 1908 into the 1940s. Dan (standing fifth from the left) and his wife, Viola (standing fourth from the left), were both part of this road camp.

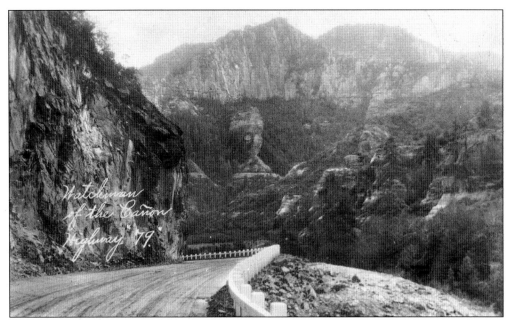

WATCHMAN OF THE CANYON, 1930s. Because improvements to the still-dirt canyon road in the 1930s were under the oversight of the U.S. Bureau of Public Roads, it was assured that it would become a highway. Postcards like this one were especially popular with the motoring public of the day. The card still refers to the highway by its old number, 79. The renamed Highway 89A became the first designated scenic highway in Arizona.

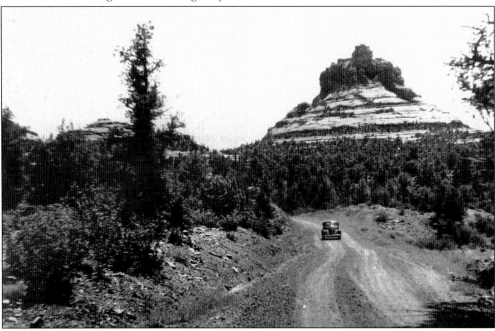

THE ROAD FROM BIG PARK TO SEDONA, 1930s. The dirt road in Big Park continued to Sedona, passing Bell Rock. It was not until development began in the 1960s that the state gave much attention to a road to Sedona. Highway 179 was widened and paved in 1961, when it connected to the new Black Canyon Highway.

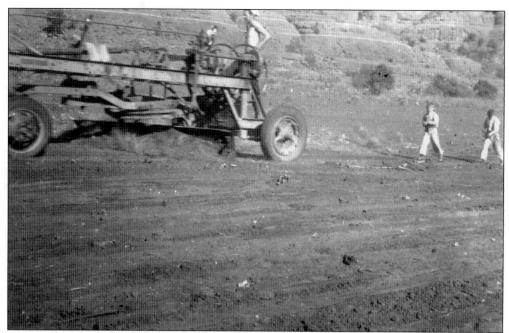

THE PIPER FAMILY WITH AN OLD ROAD GRADER, EARLY 1940S. Road-grading equipment was pressed into other uses by Sedona-area families. In this case, a grader is employed at the Lee Roy Piper homestead to level an area near the house. The Pipers were about the last to prove up on their homestead, located in the present-day Chapel area.

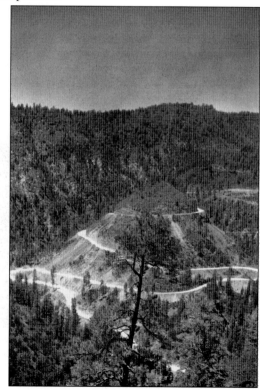

THE OAK CREEK CANYON ROAD SWITCHBACKS FROM THE AIR, 1930S. An aerial view of the switchbacks near the top of Oak Creek Canyon still shows the road surface as dirt. Interestingly, the mountain does not have the dense, mature pine tree growth that it has today. This photograph was likely attached to an advertising piece.

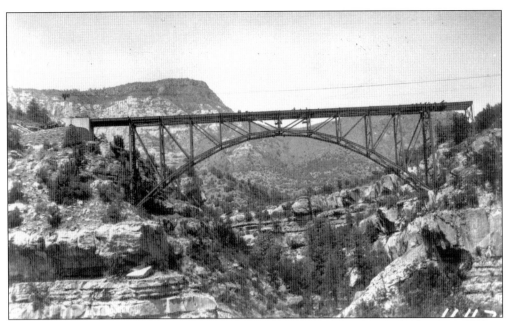

MIDGELY BRIDGE, 1939. Named for a county supervisor, Midgely Bridge was built to span Wilson Canyon and shorten the older road that clung along the sidewalls of the canyon. The bridge was finished before the new road became attached to it. As soon as both road improvements and the span were completed, the road was taken over by the Arizona Highway Department.

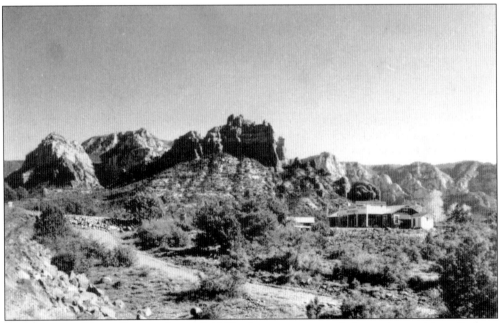

THE SECOND HART STORE. Around 1940, the state re-routed the main road into Sedona from the bridge to a new intersection with Highway 89A. This left the original Hart Store on a back street. Dad Hart and Frank Jackson built a new store along the new road, following the development pattern.

Six

TOURISM AND TRAVEL

Sedona's earliest visitors were not necessarily what comes to mind when one thinks of tourism today. Adventuresome Easterners, intrepid newspaper reporters acting as correspondents in the Wild West, and soldiers from nearby Camp Verde came to spend time fishing and sightseeing around Oak Creek.

In the 1880s, the Thomas family owned a stretch of property around West Fork. Part of the land was sold to Mary Sisson, who started a lodge. One guest made Sedona famous: Zane Grey, who visited and was inspired to write *Call of the Canyon*. In 1925, Carl Mayhew began operating Mayhew's Lodge, hosting celebrities of all stripes. Pres. Herbert Hoover, Clark Gable, and Walt Disney were a few of the luminaries. At the same time that Mayhew bought his lodge, Dad Hart opened his general store, serving both tourists and locals. The building still stands at the corner of Brewer and Ranger Roads. It was not until after World War II, however, that Sedona drew many tourists.

The 1940s were a watershed for Sedona commerce, with the building of Cook Cabins, Sunset Court, and the Oak Creek Market and Tavern. Roberts Motel and Canyon Portal opened as well. The town was now open for business. In the next decade, Purtymun's Adventure Motel and the Venture Inn Café would both be established, sporting names evocative of the happy nature of the 1950s.

Perhaps the most self-evident tourist attraction of Sedona is simply the land itself. Hiking West Fork, splashing down Slide Rock, and exploring Boynton Canyon have always been popular activities. Campgrounds strung along the creek give visitors who prefer nature a place to stay. The town's reputation as a tourist destination got a boost by the opening of Poco Diablo in the mid-1970s, known until then as the Doodlebug Ranch area. Some locals marveled that one could have an elegant meal overlooking willows and lawns without leaving town.

Sedona has long drawn New Age devotees. But in 1987, being selected as one of the most desirable sites to celebrate the Harmonic Convergence—along with Machu Pichu and Stonehenge—solidified it as a mecca for seekers of all manner of alternative philosophies and practices.

Today Sedona hosts almost as many visitors as the other canyon to the north: the Grand Canyon. Jeep and helicopter tours, gallery and boutique shopping, fine dining, hiking trails, and spas all draw enthusiasts.

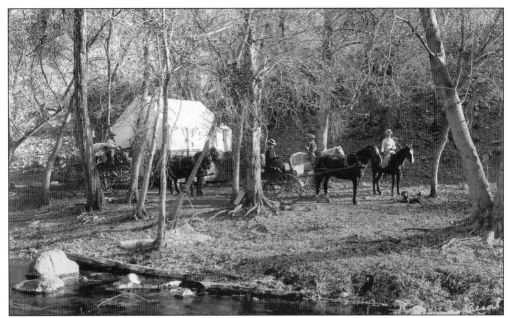

OAK CREEK TOURISTS, 1890S. Oak Creek and the beauty of Sedona's red rocks have been an enticement for visitors since being discovered. Early miners and smelter workers from Jerome and Clarkdale found Oak Creek attractive for hunting and fishing. Families from Jerome and Flagstaff, along with mountain cattle men, traveled to the canyon for its beauty, wildlife, and the cooling waters of the creek itself.

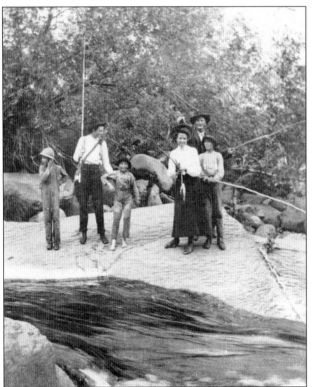

SPORTSMAN'S DELIGHT, OAK CREEK, EARLY 1900S. Natural fish ponds near the head of the canyon were deep, clear, cold, and full of large trout, as was the entire creek. Fishermen packed their catch in salt and mountain fern leaves. Hunters went for bears, lions, deer, and quail. Sportsmen's interest was high enough that Albert Purtymun collected money from some to help pay for blasting supplies to finish the canyon road.

RESIDENTS ENJOYING THE CANYON, EARLY 1900S. Early roads were poorly built and people lived far apart, so neighbors only saw each other occasionally—usually on holidays. When they met, there was music and food. Favorite dishes included fried fish, wild grape or berry dumplings, and homemade ice cream. An accordion, violin, and an occasional guitar or banjo provided music at these gatherings.

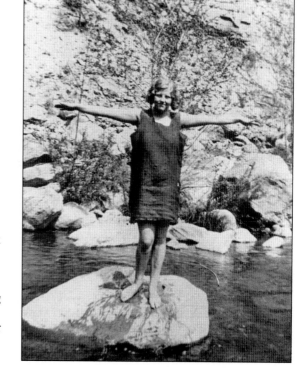

VERA PURTYMUN AT HER FAVORITE SWIMMING HOLE, 1920S. Some naturally occurring depressions in Oak Creek made perfect swimming holes. Oak Creek Falls (now Slide Rock) was a popular place to splash around on a hot day. One pioneer told of swimming in the creek with his brothers when a bear came to join them. They left their clothes on the creek bank and ran for the family's doorless cabin.

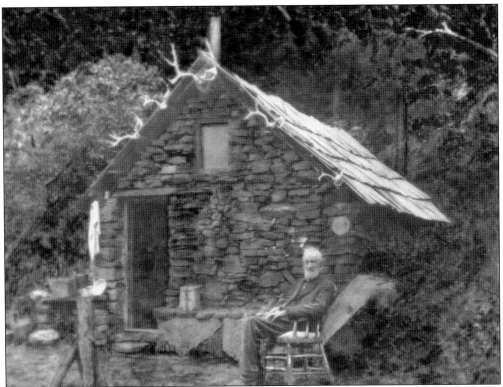

LOU THOMAS AND HIS CABIN, 1890S–1900S. Bear Howard and Lou Thomas owned land that was later home to three canyon lodges. The different parts became Lolomai Lodge, Mayhew's, and Call of the Canyon Resort. The Vandevers were running Lolomai Lodge in 1921 when Zane Grey stayed in a cabin on their property to write *Call of the Canyon*.

LOLOMAI LODGE, ESTABLISHED 1906. Lolomai Lodge was built as a summer home for Mrs. F. W. (Mary) Sisson on three acres in Oak Creek Canyon. She turned the home into a lodge because of the many visitors. A brochure advertised the spot as "a fishermans paradise and ideal resting place . . . with open air sleeping accommodations if preferred . . . for $3–3.50/day. No consumptives or invalids taken." It closed sometime in the 1920s.

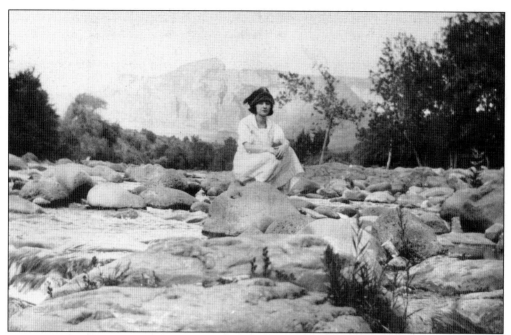

HONEYMOON ON OAK CREEK, 1922. Newlyweds Allen and Stella Bristow decided to honeymoon in the Verde Valley. They drove over the rough road to Sedona and spent "a very happy day in the solitude of the Red Rocks." Just south of the site of today's bridge, the couple picnicked and Allen took this photograph of his bride. Then, as now, the area was recognized as "everywhere a photographer's delight."

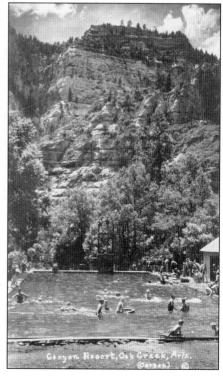

CALL OF THE CANYON POOL, 1930s. In 1926, at the county courthouse in Flagstaff, Ray Simpson bought property along Oak Creek for taxes owed. He renamed it Call of the Canyon. Between 1926 and 1948, Ray expanded the existing building and constructed an Olympic-size pool with both low and high dives. It was the only public swimming pool in northern Arizona in the 1930s and 1940s. Admission was 50¢.

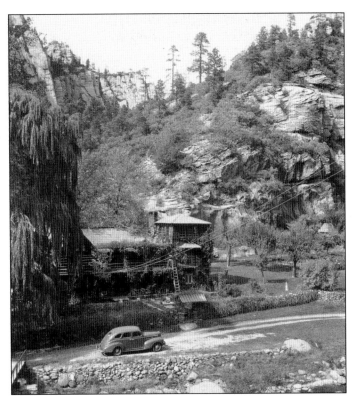

OAK CREEK LODGE, 1926–1969. Carl Mayhew took one look at the two hand-adzed log cabins, one of which had been Bear Howard's, and decided to buy them. In 1926, he opened the newly named Mayhew's Oak Creek Lodge. By the 1940s, the expanded lodge had gained a national reputation. It lacked indoor plumbing and did not have electric lights until the Mayhews put in their own Kohler plant.

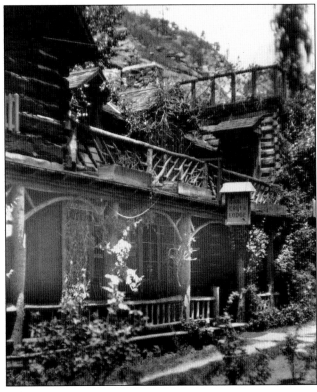

MAYHEW'S HOSPITALITY. Mayhew's cabins were shaded by weeping willow, cherry, and apple trees. Ethel Mayhew's flower gardens of county fair award-winning roses graced the property. A daily cost of $10–15 per person included three delicious meals served family style. Watermelon and drinks were kept cool in the spring house. After the lodge closed in 1969, the Forest Service acquired the site. The building burned down in 1980.

BUD BROWN GIVING EASTERN TOURISTS A WESTERN ADVENTURE, 1910S–1920S. Teddy Roosevelt's love affair with the West and the "strenuous life" inspired Americans to explore. An expedition like those offered by this outfitter might include camping under the stars, fishing, hiking, visiting local ranches, and exploring local Native American ruins. The Depression had a negative effect on these kinds of operations, which were dependent on the well-to-do.

FOXBORO GUEST RANCH, 1927–1936. Frederick Fox had made a fortune in real estate back East when he bought a ranch on the Mogollon Rim in 1922. In 1926, he returned and decided to build a camp for the pampered sons of wealthy Easterners. It soon became a major stopping point on the road between Phoenix and Flagstaff. The family hosted a steady stream of travelers, including celebrities, until closing because of the Depression.

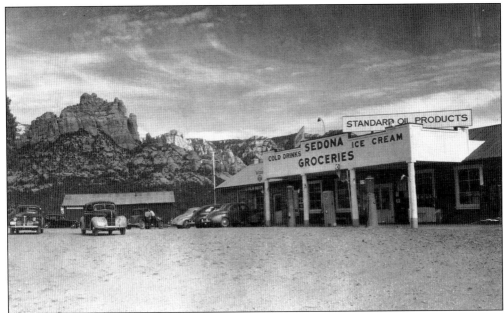

THE SECOND HART STORE, 1947. After World War II, increased leisure time and greater mobility led to increased tourism countrywide. Local businessmen began to cater to this new tourist trade. Between 1945 and 1950, the Oak Creek Market and Tavern and Rainbow's End opened, the Jordans constructed a fruit sales building from rock, and a half-dozen or so motels welcomed guests.

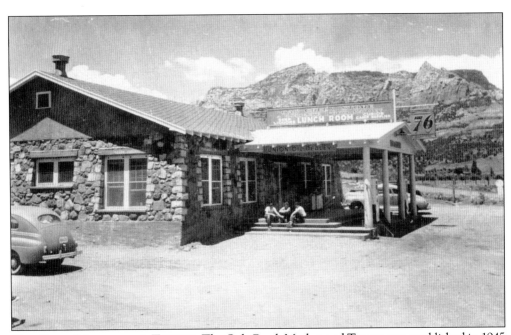

OAK CREEK MARKET AND TAVERN. The Oak Creek Market and Tavern was established in 1945 to serve both locals and those traveling down the canyon road. Though small, Sedona was always a social town. Upcoming activities were advertised through hand-written flyers posted at the Upper Store, as the market was called. Everyone was invited, including visitors and motel guests.

The Roberts' Motel, 1940s. D. K. Roberts and his wife, Jennie Lee, bought land in Sedona in the early 1940s and moved there in 1946. They built Sedona's second motel, Roberts' De Luxe Cabins. The town's first motel (other than the Sedona Lodge) was Canyon Portal, built by Don and Ruth Willard in 1946, with an adjacent gas station. In the early 1950s, the Willards added Canyon Portal Hardware and a lumberyard.

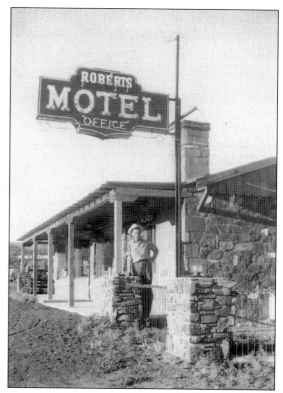

The Roberts' Motel, the Beginning of the Tourism Boom. Within a decade of construction of Sedona's first two motels, there were about two dozen places to stay in Oak Creek Canyon, including modern motels and campgrounds. The town had two art centers and several restaurants. The effort to find balance between visitors' and residents' needs began with complaints of congestion and private property signs shutting out hikers.

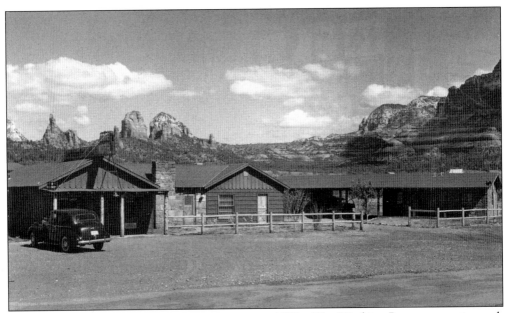

THE HITCHING POST MOTEL AND RESTAURANT, 1950S. The Hitching Post was a native rock motor-court-style motel with entry from Highway 89A and exit onto Jordan Road. It was built in 1948, and its restaurant was built the next year. The Continental Bus Company made regular stops at the café. The two were torn down in 1971–1972 to build an office complex, which now holds retail stores.

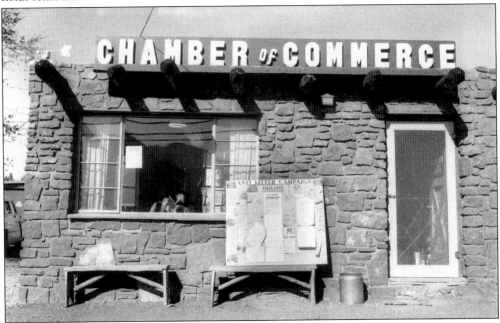

CHAMBER OF COMMERCE, ESTABLISHED 1949. The chamber leased land from the Forest Service for a new office and visitors center in 1953. When the Forest Service sold the land, the Lions Club bought a small piece so that the chamber could stay. Architect Howard Madole designed the building, and the labor was donated. One of the chamber's early promotions was to publicize Sedona's weather on radio stations.

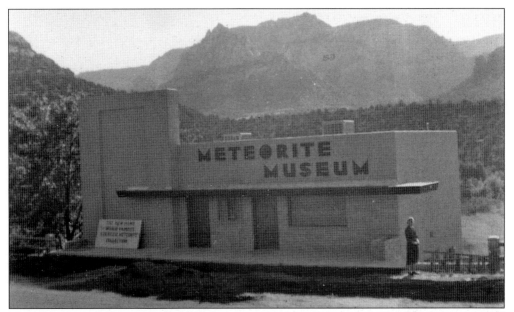

THE METEORITE MUSEUM, 1950s. While researching Meteor Crater, Dr. H. H. Nininger operated a museum on its rim, but road realignment forced the shop to close and the family to move. In 1953, the Niningers arrived in Sedona and built a new museum. Dr. Nininger's collection of meteorites was the second largest in the world. He is considered the founder of the modern science of meteorites.

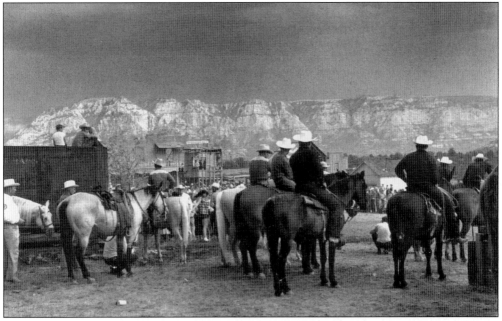

THE COCONINO COUNTY SHERIFF'S POSSE. Started in 1954, the posse acquired a 120-acre Forest Service lease next to Sedona's old Western movie set. The posse built a rodeo grounds there and held friendly competitions for sheriff's departments from all around the state. The facility became a community gathering spot for barbecues, special events, the town parade, and the posse's activities. The area was turned into a community park in 1969.

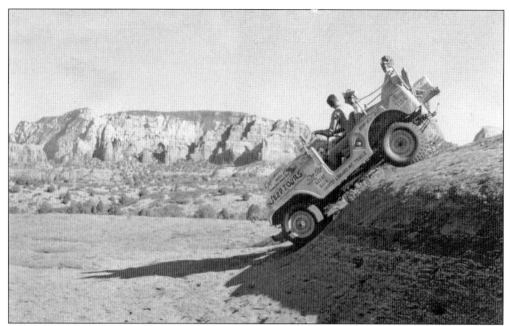

THE JEEP TOUR BUSINESS, 1960S. Don Pratt, owner of the Sedona Development Company, bought an old 1946 jeep to take family and friends into Sedona's backcountry. Visitors enjoyed themselves so much he decided to start a jeep tour. Pratt said he painted the jeeps pink because of the pink buggies he had seen in Hawaii. He also used the jeeps to show real estate.

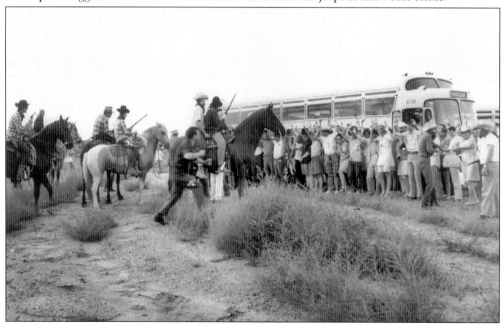

OLD WEST HOSPITALITY AND CREATIVITY, SEDONA-STYLE, 1960S. This "hold-up" of a visitor bus was a creative promotion for the town. A chamber of commerce volunteer once saw a traffic jam at the junction of Black Canyon and 89A Highways south of Flagstaff. He recommended the Oak Creek Canyon route to delayed motorists and then led a parade of out-of-state cars down the canyon and into town.

Seven

GOVERNMENT

Early residents did not depend on the government for help or handouts. What they needed, they grew or made. One of the few exceptions was voting in federal elections. Clara Schnebly McBride, the daughter of T. C. and Sedona Schnebly, recalled that her father would fetch ballots from Flagstaff on market day and bring them down to his farm. On election day, men would ride up on their horses to mark their votes, some not even dismounting, after which T. C. loaded up the completed ballots to return to Flagstaff.

The first step toward township was to create a post office. T. C. seemed eager to do anything that involved activity and interaction, so he applied for approval of a post office name. His first choice was Schnebly Station. But he received a rejection; adding "Arizona Territory" to the postmark exceeded the physical limits of a round cancellation stamp. (Arizona would not become a state for another 10 years.) T. C.'s brother Ellsworth famously suggested, "Why not name it after Dona?" No one recorded Sedona's response, but surely pride and embarrassment mixed. And so the town was named.

Everyone who lived in Sedona in the early days knew William "Billy" Wallace. Wallace had been one of Teddy Roosevelt's Rough Riders in the Spanish-American War. When Roosevelt became president and established the Forest Service, Wallace was one of the former Rough Riders appointed to serve as a ranger. He was pretty much on his own, stabling his horses in an old log building with a corral outside by his cabin. About 12 years later, an official Forest Service residence was constructed. Early rangers were fire lookouts—and firefighters, if necessary. They also surveyed, mended fences, and supervised homesteaders proving on claims. A less traditional but highly enjoyable responsibility was providing the annual Christmas tree for school programs. In 1935, the Civilian Conservation Corps (CCC) added a barn to the site.

Pres. Franklin Roosevelt established the CCC in 1932 to provide work for men without jobs during the Depression. Sedona CCC enrollees performed various jobs in the area for the U.S. Forest Service. In 1935, the CCC installed poles for electrical wire, in order to bring power to the town. Will Steele was among the first customers.

Sedona did not have any official city government until its incorporation in 1988.

Camp at Oak Creek, 1880s. The army officers of Fort Verde often camped along Oak Creek for rest and relaxation. They called the spot Camp Garden, and it was perhaps the first government installation in red rock country, although temporary. A popular campsite along a wash just upstream from the creek came to be called Soldier Wash, a moniker that continues today.

Theodore Carlton Schnebly, Sedona's First Postmaster. When T. C. Schnebly applied for a post office in Sedona, he listed the population as 55. His pay was $20.70 for the first year, and an estimated 25 to 30 letters a month were mailed during those early years. When T. C. left town with Sedona, his brother Ellsworth took over. In 1910, Ellsworth's wife, Mary, became Sedona's first woman postmaster.

BILLY WALLACE, SEDONA'S FIRST FOREST RANGER. Pres. Theodore Roosevelt appointed Rough Rider comrade Billy Wallace to the new Sedona Ranger Station in 1905. But Billy wanted to homestead. Because the ranger oversaw the homestead program, he faced a conflict of interest. After much correspondence, Billy left the Forest Service to homestead near Flagstaff.

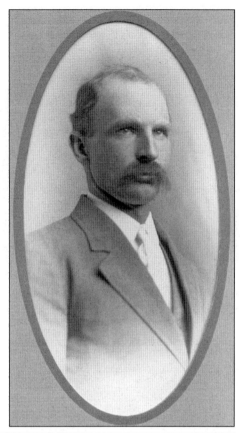

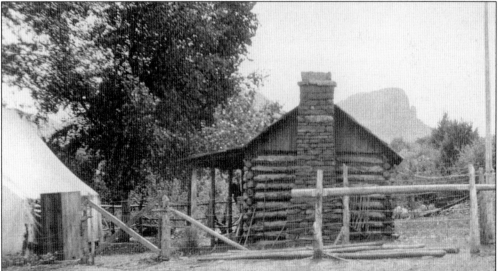

THE SEDONA RANGER STATION, C. 1905. The first Sedona Ranger Station was a two-room log cabin, then serving as both home and office for the ranger. In those days, a ranger owned his own saddle horse and pack animals. In the 1930s, it was discovered that a survey error had placed the station on the wrong land. The Forest Service then traded land with a neighbor to correct the error.

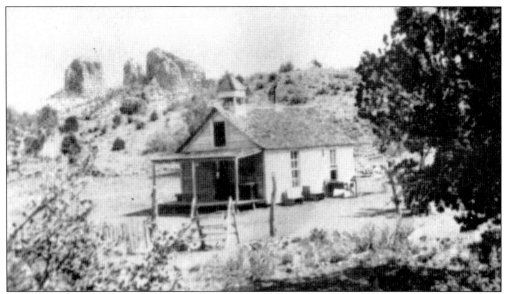

RED ROCK SCHOOL, ESTABLISHED 1891. Red Rock School District No. 27 was the area's first school. During the first year, an existing cabin acted as the schoolhouse. A real schoolhouse was built without government help by the Schuermans and their neighbors on the Schuerman farm at Red Rock. Minnie Maxwell served as the first teacher. As was common in those days, she boarded at the Schuerman home.

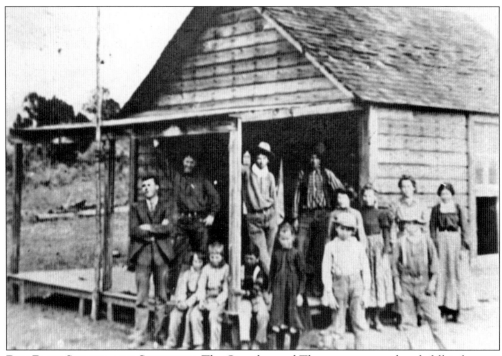

RED ROCK SCHOOL AND STUDENTS. The Owenbys and Thompsons moved each fall to be near to this first school so their children could have a few months of education. The Chavez children rode burros from their home at Chavez Crossing. The Huckabys lived nearby. In the 1930s, the WPA built a rock addition that included a stage. The school closed in 1948.

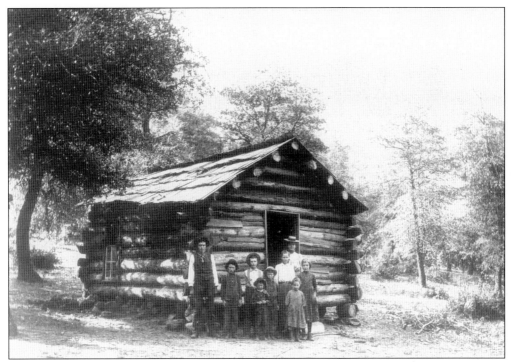

THE OAK CREEK CANYON SCHOOL, ESTABLISHED 1899. This school stood halfway between the Thompson and Purtymun homes. That way, each family's children had only three miles to walk. Ellsworth Schnebly was the first teacher in this log cabin school, which was heated by a big wood-burning stove. In 1901, the roster showed 13 students: 6 Thompsons, 6 Purtymuns, and 1 Thomas (Bessie).

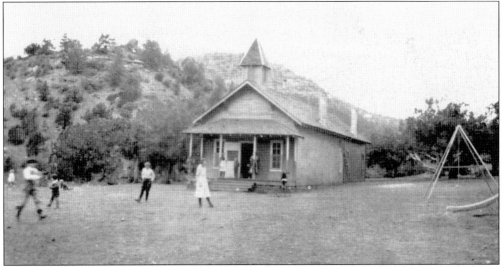

THE SEDONA SCHOOL, ESTABLISHED 1910. Frank Owenby Sr. leased land for the school on Brewer Road for $1 per year. At this time, four Sedona families had children. Coconino County paid enough money to build a small schoolhouse, about 16 by 12 feet in size. The first teacher was the ranger's wife, Mrs. Claude Thompson. Mountain cattlemen began to build winter homes in town and send their children to this school.

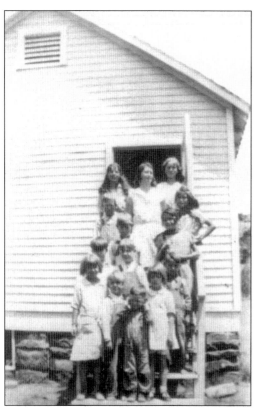

THE BIG PARK SCHOOL, 1930S. The Harper family arrived in Big Park in the late 1920s and filed for homestead. Homer did not want his six children to have to cross Oak Creek to attend the nearby Red Rock School, so he built a school on the east side of the creek. This school was later moved farther east, closer to the main road. It closed in 1941.

THE JACKSON SCHOOL, 1940S. In the mid-1920s, about half the children enrolled in the Sedona School came from Grasshopper Flat. But that side of town lay in another county, and so those families were not represented on the school board. Eventually, Yavapai County provided materials and James Jackson furnished labor for a new school, which opened in 1925 and closed in 1943.

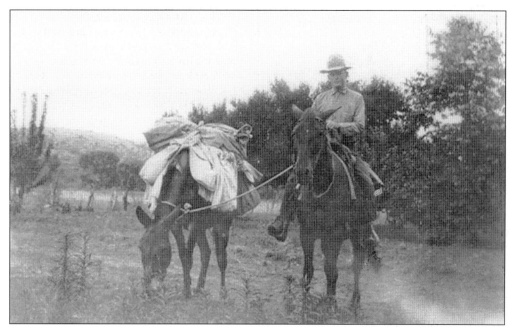

GLEN GIRDNER DELIVERING THE MAIL, C. 1919. Sedona's mail came to the post office by horseback mail carrier until the 1920s. Glen Girdner held the contract for the Cornville–Sedona service. He jokingly referred to his route as the "try-weekly" mail route because he tried weekly to complete the trip. When the creek was high, Glen sometimes threw the mail across to residents on the other bank.

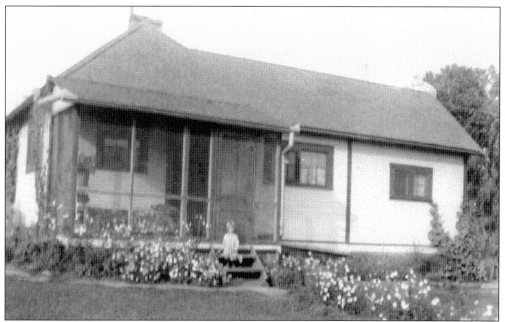

SEDONA RANGER STATION, EARLY 1930s. Ranger Jesse Bushnell asked Washington headquarters for money to build a new home and station; in return, he received some regulation drawings. He did not get enough money to finish the structure, but it was completed with the help of neighbors. The Bushnell family finally moved into their new home in 1917.

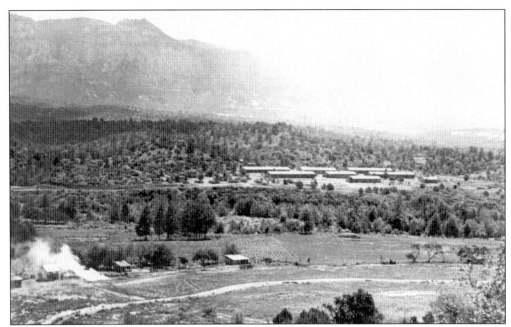

SEDONA CCC CAMP, 1930s. During the Great Depression, Sedona was home to the 311 Company of the CCC, consisting of about 200 men. Their camp stood along the road just south of the Sedona bridge. These men built a new barn at the Sedona Ranger Station, constructed a pump house that supplied water to the station and to the Sedona School, and installed electric lines into town.

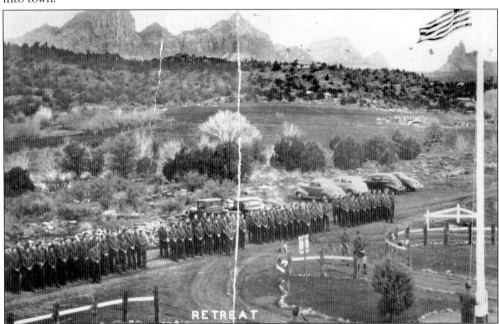

SEDONA CCC MUSTER, 1930s. A CCC man's life in camp centered on military-style routines and hard physical work. However, weekends included dances at the local school. Many local girls of that time said they learned to dance with the CCC men. The Forest Service used CCC labor on Schnebly Hill Road, area dams, fences, trails, and erosion control projects.

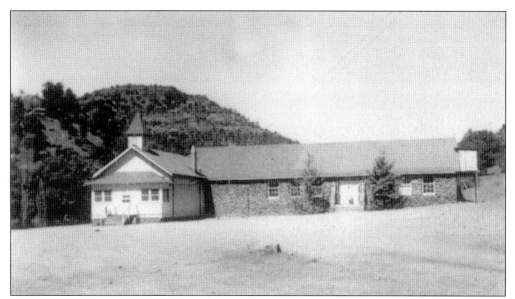

THE SEDONA SCHOOL AND AUDITORIUM, 1937. The WPA, another Depression-era program, built a rock auditorium onto the Sedona School. The largest building in town, it served as a community center. The American Sunday School Union met there for services, and dances and potlucks were regular activities. The building burned in 1948. Until a new school was built, classes were held at the Sedona Ranger Station.

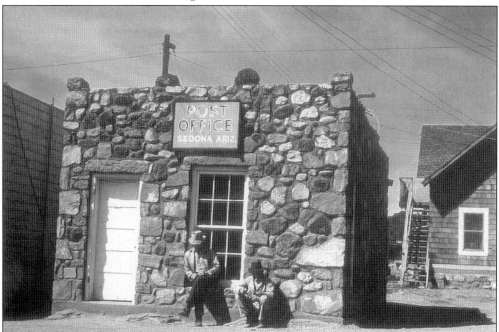

SEDONA POST OFFICE, LATE 1940S. Returning from World War I, Charley Thompson took over the post office from his dad. After the 1938 flood damaged his home, which also housed the post office, Charley constructed a building along the road, high above the creek. Ed Black bought Charley's property and built this structure—the first to house just the post office and no other businesses or a residence.

WILL STEELE, COCONINO COUNTY DEPUTY. The unincorporated village of Sedona straddled a line between two counties: Yavapai and Coconino. Law enforcement from both worked in cooperation. In 1940, Will Steele became the first part-time Coconino County deputy based in Sedona. When he passed away in 1951, his son Will was appointed to a new full-time deputy position.

SEDONA RED ROCK NEWS

The Voice of Sedona and Oak Creek Canyon for **25** Years

VOLUME XXV, NUMBER 17, WEDNESDAY, JANUARY 13, 1988 SEDONA, AZ PRICE 35 CENTS

June Cornelison chosen mayor

Council holds first meeting

by Cathalena E. Burch
Red Rock NEWS staff

The Sedona City Council got its first taste of the inner workings of city government Monday night, and if the 2½ hour meeting is any indication, the seven-member council is going to have their hands full during the next six months.

Roughly 75 local residents attended the first city council meeting, held in the library at the West Sedona Middle School. Two representatives from the League of Arizona Cities and Towns also attended the meeting to assist the new council with their arduous task.

"I would like to let you know that we are behind you," commented local resident Thron Riggs.

The first order of business for the infant council was the selection of Sedona's first mayor and interim city clerk. The council voted unanimously in favor of Councilwoman June Cornelison as mayor and Pat Turner as city clerk.

All of the council members are volunteering their time to help establish the "skeleton" of Sedona's city government.

The city council's task, according to Cathy Connolly, assistant director of the League of Arizona Cities and Towns, will be to establish city ordinances regarding taxes, elections, law enforcement, and the city's budget, among other things.

Jeff Martin, senior staff associate with the

League of Arizona Cities and Towns, said the newly-formed city of Sedona can expect to receive about $420,000 from state-shared sales tax and highway user revenues for the next six months. The monies are given annually to incorporated towns and cities in Arizona based on their estimated population.

Martin said the state will pay Sedona the money dating from one full month after the city was incorporated. The state is basing the amount on Sedona's 1980 census date from the federal government.

"You're going to want to get a special census with the tremendous growth in Sedona," he advised the council. "You are now going to share a certain pot of money based on your population. If you don't have a special census, you're going to get a much smaller share of that pot."

The 1980 census figures, which included what was then considered the boundaries of Sedona, placed the population around 5,000. Martin noted. Martin said the estimated cost of having the U.S. Bureau of the Census conduct a special census would be in the neighborhood of $20,000, but the city could benefit with higher state-generated revenues.

The council will not receive the state monies for at least two months, Martin noted. In the meantime, the League of Arizona Cities and Towns representative suggested that the council open a "warrant account" with a local bank. The account, which will cost the city 6 percent in in-

terest charges, will be similar to an open charge account.

The city council can also look forward to an additional $1,500 to work with, thanks to the pro incorporation group Citizens for Incorporation. Pat Kantor, former chairwoman of the now dissolved group, donated CFI's remaining monies to the city treasury.

While Sedona's monetary situation may look bright, the state of local elections is in total disarray. Connolly said because of the date of Sedona's incorporation, local residents interested in running for the first elected council have less than a month to gather the necessary signatures to get on the ballot.

Connolly said potential candidates need signatures from "not less than 5 percent and no more than 10 percent" of the voters who participated in the Dec. 2 incorporation election. The deadline for candidates to file is Friday, Feb. 5.

According to state election statutes, the city council must call a primary election for Tuesday, April 5, followed by the general election on Tuesday, May 17.

Connolly said the council may want to move one of the dates to accommodate local voters and candidates and to comply with state statutes.

"There's no way that you can comply with all of these," she explained. "The key is to preserve the rights of your voters."

Also during the meeting, the city council voted to allow public participation during the beginning of their regular meetings. Residents wanting to

Mayor Cornelison

JUNE CORNELISON, SEDONA'S FIRST MAYOR, 1988. For decades, area residents debated both the pros and cons of incorporating as a city. The debate was divisive and sometimes bitter. When the State of Arizona required proper sewer management and treatment to protect water quality in Oak Creek, the debate ended in a vote. Sedona incorporated in 1988. The city's first town council elected one of its own members as Sedona's first mayor. (Courtesy Larson Newspapers.)

Eight

CINEMA

Most everyone who has visited Oak Creek Canyon has pointed a camera at some spectacular vista or rock formation, trying to capture the drama and grandeur. With the striking contrast between red rock and blue sky, Sedona naturally became a favorite filming location for Hollywood studios.

About 100 movies have been shot in and around Oak Creek, although it has generally doubled for another locale, even serving as the Canadian Rockies in a story about mounted police. For this, yucca and other cactus had to be removed from film sites, replaced by tall ponderosa that had been cut near Flagstaff and hastily "replanted" among the red rocks. The golden age of the Sedona movie industry hit in the 1940s and 1950s, when every major studio and many famous movie stars traveled to Oak Creek for one film or another.

California, a film shot in 1946, starred Barbara Stanwyck and Ray Milland. It included the impressive but fictional sequence of wagons being precariously lowered off ledges along Schnebly Hill Road; although this never happened in real life, it did make an excellent visual. Some early residents recalled spending the day watching the elaborate process involving harnesses, hitches, and hooves the movie company employed to shoot the scene.

During the filming of many pictures, Sedona resident Bob Bradshaw was present. As a young man, he worked as a wrangler, stuntman, and extra in many of the films during the 1940s and 1950s, when Westerns hit their heyday. A photographer as well as a movie double, Bradshaw became an informal cinema historian of local films. His photographs capture a young John Wayne in the 1946 film *Angel and the Badman*, Robert Mitchum in 1948's *Blood on the Moon*, Rock Hudson in 1953's *Gun Fury*, and scores of others. Bradshaw went on to open a local photography shop and publish books of his images.

The 1960s saw the end of the Western era. One of the last movies shot during the decade was John Wayne's *The Comancheros*. In 1965, an all-star cast came to Sedona to shoot *The Rounders*, including Glenn Ford, Denver Pyle, and Henry Fonda. During the filming, the stars mixed with residents at events held in their honor.

RIDERS OF THE PURPLE SAGE SET. In his early days, Zane Grey had control of where his films were made, and he required they be shot where the novel was set. In 1923, a crew arrived to make a silent film version of his *Call of the Canyon*. This was Sedona's first but not last film crew. Grey returned a few years later to make *Riders of the Purple Sage*.

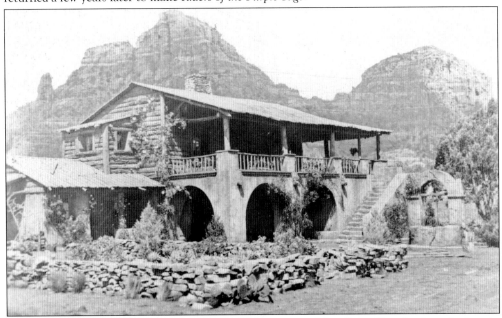

RIDERS OF THE PURPLE SAGE, 1931. Much of the action of this Zane Grey book took place in Little Horse Park, now known as the Chapel area, where an elaborate set was constructed. George O'Brien stars as the hero who saves Marguerite Churchill's character from villains who want her run out of town in order to claim her land. This elaborate set was burned for the film.

CESAR ROMERO, 1939. The star of *Viva Cisco Kid*, Romero arrived in Sedona with the 20th Century Fox production crew. He posed for this snapshot by a local fan. The company had to make two trips to Sedona to complete shooting because of bad weather. Romero played a charming hero looking for an orphaned infant in a film with plenty of action but surprisingly little violence for the genre.

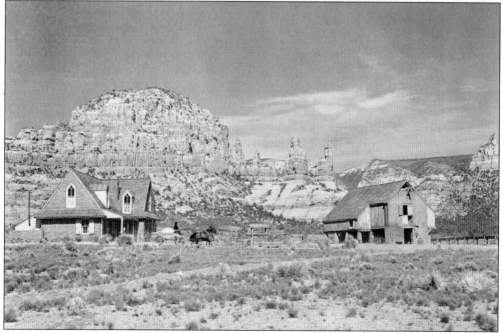

ANGEL AND THE BADMAN, **1946.** John Wayne had been to Sedona in 1944 to film RKO Radio's *Tall in the Saddle*. In 1946, Republic Studios gave him the opportunity to produce his first film. John Wayne's initial effort as a producer, *Angel and the Badman*, was shot almost entirely in Sedona.

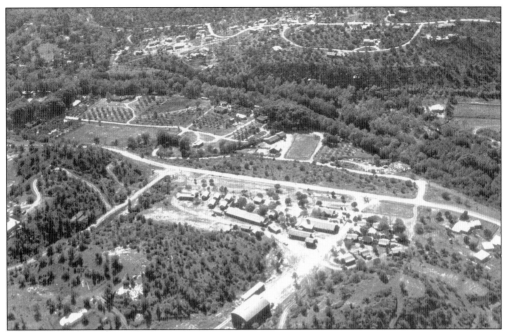

LITTLE HOLLYWOOD, 1940s. Local outfitter Oscar Giles approached John Wayne and promised to build a motel, movie set, and soundstage (bottom center building) if Wayne would bring his *Angel and the Badman* production to Sedona. The two struck a deal, and John Wayne was the first to use several new locations built just for the movie industry. (Courtesy Bob Bradshaw.)

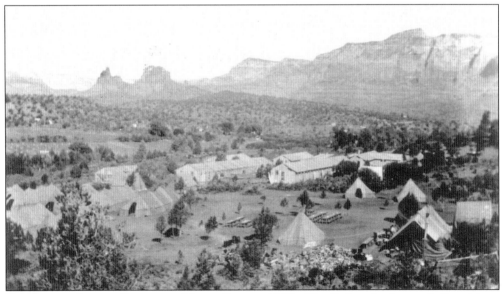

THE SEDONA LODGE, READY FOR MOVIE CREWS, 1940s. The Sedona Lodge was built to house 300 people—or two movie crews—which speaks to the popularity of the location. The lodge was demolished in 1964 to allow for a new hotel. The lodge and soundstage were situated on the approximate site of today's King's Ransom Motel. (Courtesy Bob Bradshaw.)

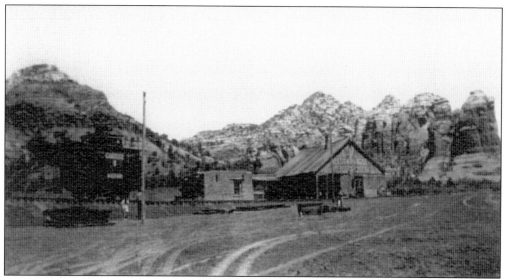

WESTERN TOWN MOVIE SET, 1946. During the shooting of *Angel and the Badman* was the only time a train ever existed in Sedona, this short stretch being imported just for the film. The area is now the Sedona West subdivision, where the streets are named for movies made in Sedona. The set was demolished about 1959.

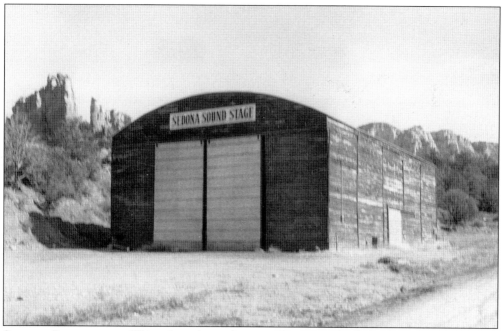

SEDONA SOUNDSTAGE. This relatively modest soundstage was built for interior *Angel and the Badman* scenes. Sedona's overall good weather insured that it got little use. The space was considered for the Sedona Youth Center and was employed for the storage of paper recycling before being demolished in the late 1960s.

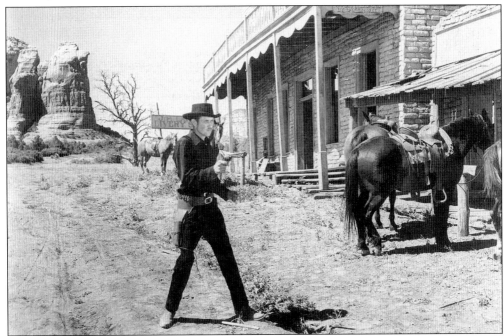

BOB BRADSHAW, *ACE RANCHERO* PROMOTIONAL, 1950S. Bob Bradshaw arrived in Sedona in 1946 at the height of Western movies' popularity. Bradshaw later developed a small Western town television and movie set out of town. It was burned down for a Wells Fargo commercial. (Courtesy Bob Bradshaw.)

THE REDHEAD AND THE COWBOY, 1951. Faye Crenshaw (pictured here) was an expert horsewoman eking out a living in Sedona when she started working as a stand-in for the female stars of movies. She doubled for Rhonda Fleming on this film, which also starred Glenn Ford (left) and Edmond O'Brien (right). At Ford's goading, Fleming attempted one stunt on her own, but her horse reared up and fell backward on top of her.

COMANCHE TERRITORY, 1950. This Universal Studios production starred Maureen O'Hara and MacDonald Carey. Carey plays Jim Bowie, who stumbles across a plot among white settlers to attack a local tribe. The film was an early and unusual attempt to portray Native Americans in a sympathetic light. It was also considered very historically inaccurate, mixing timelines, costuming, and the dress of several different Native American tribes.

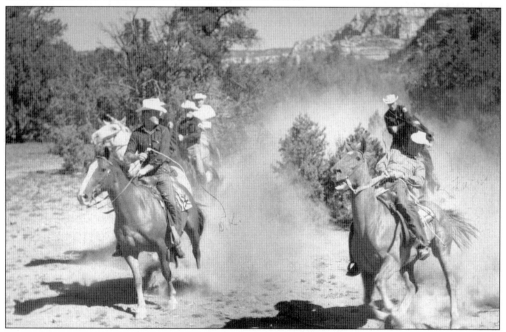

PONY SOLDIER, 1952. Filmmakers came to Sedona even though the territory looked nothing like the Canadian border area. They were assaulted by snowstorms and a nuclear explosion 300 miles away in Nevada that disrupted filming with its light flash and hazy atomic cloud. All but three members of the cast and crew, including star Tyrone Power, suffered colds, flu, pneumonia, or an accident. Some of the horses even became sick.

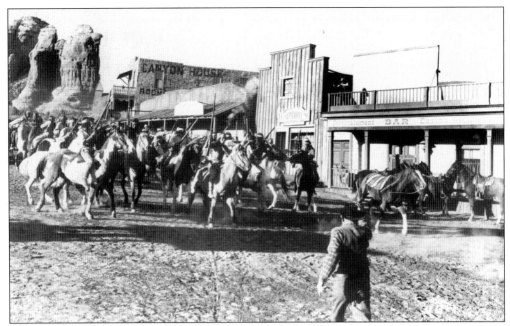

THE HALF-BREED SET, 1952. *The Half-Breed* was an RKO film starring Robert Young, Janis Carter, and Jack Buetel. It was shot in and around Sedona with scenes at the Sedona Western town set near the base of Coffee Pot Rock. An entire Native American village was built for the film. The open vistas of earlier times were starting to be crowded with rooftops, making filming for Westerns more difficult than in the past. (Courtesy Bob Bradshaw.)

SEDONA RESIDENTS WELCOME MOVIE STARS. During the filming of *The Rounders*, Sedona residents invited the cast and crew to a barbecue at the Posse Grounds—the site of the old Western movie set. At the event, the cast was honored with certificates. Here Walter Nelson (left) and Ellsworth Schnebly make their presentation to Henry Fonda.

FIRECREEK, 1966. Local cowboys Ira Smith (left) and Vic Dickison (right) worked with character actor Jack Elam (center) in this scene. The plot is typical Western fare: the folks of a small town must stand up for their rights after gunmen abuse them. Opening scenes were shot on Schnebly Hill. The creek scenes had to be shot at Dry Creek because Oak Creek was running too high at the time.

DEATH VALLEY DAYS, 1966. The television series filmed three episodes in Sedona—one in 1962 and two in 1966. The series was hosted by Ronald Reagan. Movies and television provided work for locals, who could serve as stuntmen, extras, and wranglers for the crews.

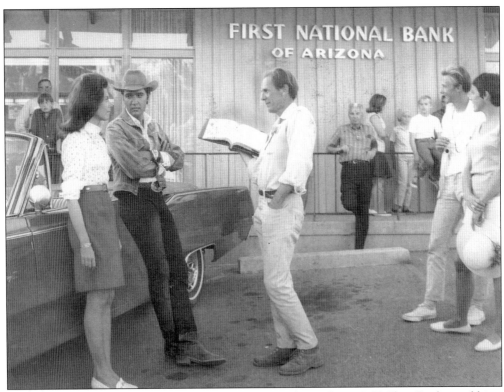

STAY AWAY, JOE, 1967. Elvis Presley and his co-star, Katy Jurado, receive instructions from the director while filming in Uptown Sedona. This was one of the rare times that Elvis's wife, Priscilla, and the wives of his entourage attended a location shoot. Filmed in Sedona and Cottonwood, the movie wrapped on November 27, 1967, with a lunch Elvis had catered for the cast and crew.

AL NUANEZ, MID-1980s. Al Nuanez arrived in Sedona as an orphan and was raised by the Chavez family. He appeared in at least five Sedona movies, sometimes as a stuntman. In a Mexican-produced film, he played a Native American chief. Of all the movies in which he appeared, this was the only one he ever saw. Nuanez also worked at the Verde Valley School teaching horsemanship, among other things.

Nine

ART SCENE

From the ancient Sinagua tribe leaving enigmatic petroglyphs on the canyon walls around Oak Creek to today's photographers and painters, Sedona has inspired people to create artwork. Bob and Mary Kittredge were sculptors who came to Oak Creek in the 1930s. They built Forest Houses Resort and both received commissions for public art from the WPA. In addition, early Sedona residents Frieda Loy, Sarah Jane Farley, Helen Jordan, and others painted for their own pleasure.

In the 1940s, Oak Creek got a close-up interaction with the art world when Max Ernst arrived. A surrealist painter associated with the Dada movement (a cynical abstract period after World War I), Ernst moved to Sedona with Dorothea Tanning. Other prominent artists visited him in Oak Creek. Ernst's friend Nassan Gobran, an Egyptian sculptor who taught in Boston, had been invited to Oak Creek Canyon to consider a teaching position. After seeing the movie *Broken Arrow*, shot in Oak Creek, Gobran decided he was meant to move West. He decreed that such an exquisite setting needed a place for artists to gather and create. He worked with area residents to found what would become the Sedona Arts Center in 1958. In 1961, the group moved into a packing shed belonging to member Helen Jordan's husband, George. This became known as the Art Barn. More than a studio or meeting space, the Art Barn was an informal community center. Helen Jordan began as a student at the Sedona Arts Center and eventually became a teacher.

Another major step forward for the Sedona art community occurred on a day in June 1965 when a group of friends was killing time in the Oak Creek Tavern, talking about having "a roundup of artists." Charlie Dye, George Phippen, Joe Beeler, and John Hampton had gathered to share beer and stories but left with the formation of the Cowboy Artists of America. They declared their group to be dedicated to preserving the rugged, iconoclastic ethos of early cowboy life.

New dimension was added to Sedona's art scene when popular jazz pianist Johnny Gilbert visualized a casual outdoor venue for performers. Jazz on the Rocks was born. Over the years, the festival has grown from a few hundred spectators to thousands.

SEDONA LITERARY SOCIETY, 1930S. Vendla Sides started the Sedona Literary Society in 1932. Group members gathered monthly at the Sedona School to bring culture and entertainment to local residents, as well as further their own literary pursuits. They gave pageants, readings, and plays, often dressing up as literary characters.

ROBERT AND MARY KITTREDGE. Robert Kittredge and his brother arrived in Oak Creek Canyon in 1931. Both Bob and his wife, Mary, were well-recognized sculptors of the day but abandoned the big city in order to live in this remote part of the West. To make a living, they started a tourist rental business. At least two of Bob's Depression-era New Deal art commissions still exist in government buildings in Arizona.

MAX ERNST AND DOROTHEA TANNING WITH CAPRICORN, C. 1948. Max Ernst lived in many houses, both in France and the United States, and left his mark on them. Bob Kittredge and a laborer helped him build his Sedona home, which Ernst decorated with clay or cement reliefs. Ernst created a large garden bench, naming this group of figures *Capricorn*. The sculpture was later re-created in bronze.

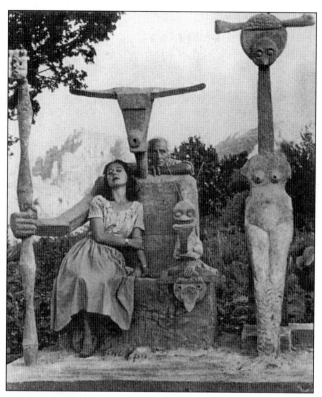

LA GALERIA, 1960s. Al Nestler moved to Sedona in 1960 and opened what is thought to have been either the first or the second fine art gallery in town. He and his wife, Ernestine, were active in the local arts scene. Al was a charter member of the Sedona Arts Center and taught classes in painting there for years. His paintings hang in permanent collections in museums across the nation and in many private collections.

Bob Bradshaw's Photography Shop, 1950s. Bob Bradshaw honed his photography skills while making a living working with movie crews and selling horse rides from the stables behind his studio. He started a tour company so he could share the beauty of Sedona with visitors. Bradshaw became a popular regular photographer for *Arizona Highways* magazine.

Treasure Art Gallery, 1960s. Artist Stephen Juharos emigrated from Hungary, where he had been painting since the age of seven. He arrived in Sedona in 1961 and built a home, studio, and gallery next to the highway, hoping to attract the growing tourist traffic. During the 1960s, he had an art instruction program on Flagstaff Television, Channel 2. He was also commissioned to paint several large murals around the country.

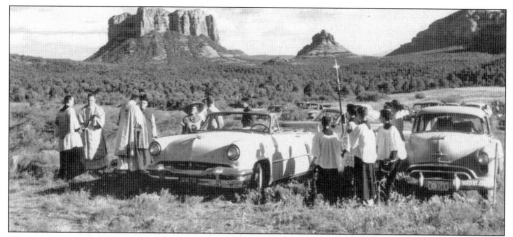

CHAPEL OF THE HOLY CROSS GROUND-BREAKING CEREMONY, 1954. Marguerite Brunswig Staude's family fled Europe to avoid the Holocaust. As a young woman, Staude (in the hat) studied art and sculpture in France and Italy. Seeing the girder system of the Empire State Building during its construction, she was inspired to build a modern Catholic chapel. With the help of Barry Goldwater, land in Little Horse Park was allocated for construction.

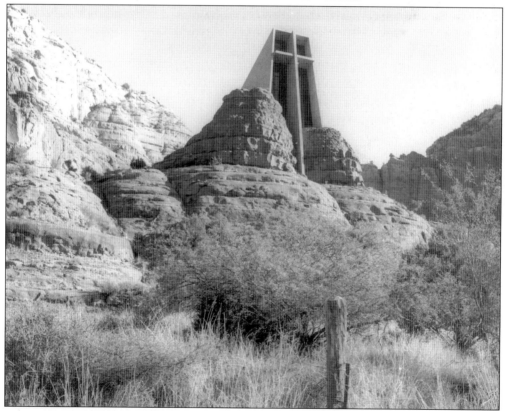

CHAPEL OF THE HOLY CROSS. The Chapel of the Holy Cross was completed in 1956. A story circulates that Staude chose the location for the church because she saw a pharmaceutical symbol in the rock. She deemed this a sign, as her father had been a druggist. It turns out that homesteader Lee Roy Piper's brand was the "Rx" and he had carved the symbol on the rock.

ZOE MOZERT, 1907–1993. Mozert was the most famous female pin-up artist ever. In the 1940s, she began painting posters of movie stars. Howard Hughes hired her to paint Jane Russell to publicize his film *The Outlaw*. She often posed for her own paintings. In 1953, Mozert moved to Sedona. In Arizona, she was commissioned to paint socialites, Babbitt family members, a governor, and billboards for the Sedona Chamber of Commerce.

GEORGE AND HELEN JORDAN, 1950s. Helen Coleman married George Jordan and relocated to Sedona in 1928. She began studying with various artists who had gravitated to the area in the 1940s and 1950s. When the Sedona Arts Center opened, she took classes and eventually became an instructor. Helen's home and studio were always overflowing with her art.

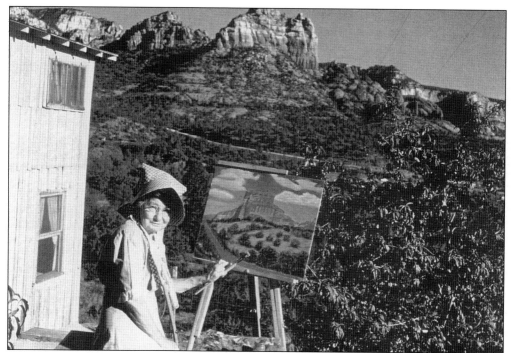

SARAH JANE FARLEY. Sedona's spectacular scenery inspired some of the earliest residents to "take up the brush." Sarah Lay (later Farley), a descendant of one of Sedona's first families, was presented with a set of paints when she was in her early 70s. She started painting after taking a handful of classes. She paid for the lessons by making and selling aprons.

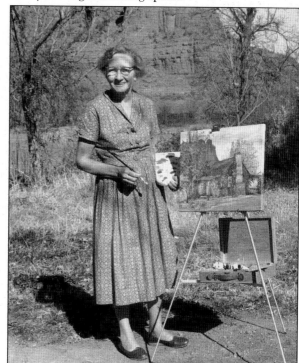

FRIEDA LOY. The Schuermans, Frieda Loy's parents, raised her in the midst of incomparable scenery at the base of Cathedral Rock. A gifted gardener, she was also involved in community affairs. But only after her children left home did she discover her artistic talent. Loy said she started with discarded crayons, then graduated to oil painting, with the red rocks her favorite subject.

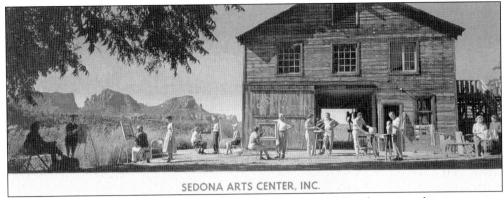

SEDONA ARTS CENTER, INC.

SEDONA ART BARN. In 1958, Nassan Gobran and a group of 12 others signed incorporation papers creating the Canyon Kiva Arts Center, later organized as the Sedona Arts Center. They established the center, in Gobran's words, "to put Sedona on the map through art." In 1961, George and Helen Jordan sold their fruit-packing shed to the fledgling arts organization. (Courtesy Bob Bradshaw.)

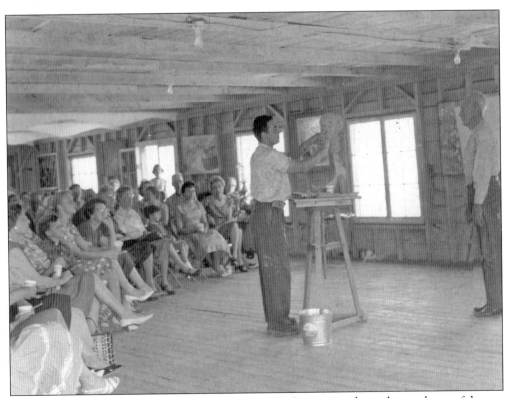

SEDONA ARTS CENTER OPENING DAY, APRIL 29, 1961. On opening day at the new home of the arts center, one of the events was a demonstration by founding president Nassan Gobran, who modeled a head in clay. The facility was still very barn-like with rough ceilings and bare lightbulbs.

COWBOY ARTISTS OF AMERICA, ESTABLISHED 1965. From left to right, Joe Beeler, Charlie Dye, John Hampton, and George Phippen decided to organize a roundup of artists whose aim would be to perpetuate the culture of the Old West, ensure authentic representation of the life of the West, protect artists' rights, and educate the public about cowboy art. Around a table in the Oak Creek Tavern, the Cowboy Artists of America was born. At far right is Robert T. MacLeod, an associate member.

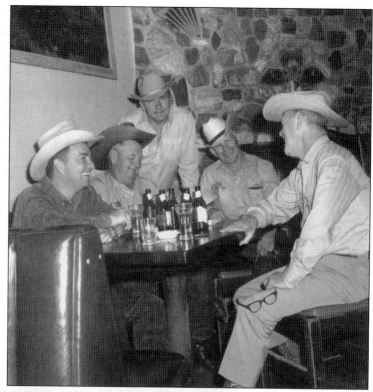

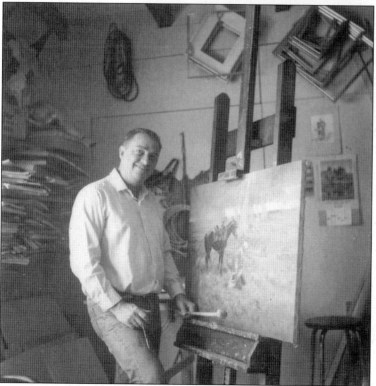

ARTIST JOE BEELER, 1965. Beeler trained as an artist, arriving in Sedona in 1961 with his family. A pioneer in the field of Western contemporary art, he had an extensive knowledge of the American West. His accomplishments brought him well-deserved recognition and international acclaim. He was a respected Sedona resident who enjoyed storytelling and cowboying with local friends.

SEDONA ARTS CENTER MORTGAGE BURNING, 1967. The arts center was a volunteer-run organization for many years. According to one story, Maud Hardman arrived at the old barn for the first time to find Cecil Lockhart-Smith washing windows. When she asked if he was the janitor, he explained that he was the secretary and treasurer. Maude vanished briefly and then returned with a bucket and sponge and set to work.

THE CHAPEL AT TLAQUEPAQUE. Abe Miller's dream would include a chapel based on the private family chapels of Mexican haciendas. Local artist Eileen Conn painted the chapel's murals and tooled its leather seats. Miller often spent private time in the chapel. He died just a few months after construction was completed on the arts and crafts village, which he spent almost 10 years on.

Ten

How We Grew

Sedona has come a long way. When the first settlers arrived, root cellars kept perishables cool and the rushing water of the creek acted as a refrigerator. Lamps burned kerosene or coal oil through the 1930s, although nearby Jerome and Prescott had hydroelectric power from plants on Fossil Creek and near Verde Hot Springs starting around 1910.

Electricity did not reach upper Red Rock Loop until the late 1940s. A war-surplus generator was brought in as part of the government's Rural Electrification Administration (REA). When electric wires were run in the 1950s, that generator was moved to Indian Gardens for canyon residents, and by the mid-1960s, most of the area had electricity. The first telephone service in Sedona was for the Forest Service. By the mid-1950s, the first telephone directory listed 150 names; in 1957, the directory included 365 names over a span of two and a half pages. People did not have to dial seven numbers until 1963.

Another step on the way to being a full-service town came in 1952 with the purchase of a fire truck. Nicknamed "the Turtle" because it climbed hills slowly, the truck carried 400 gallons of water and cost less than $3,000. Carl Richards, one of three men to sign the note guaranteeing payment of the Turtle, loaned out his garage in Uptown Sedona in lieu of a fire station. By 1961, Sedona had fire service out of both counties it inhabits: Yavapai and Coconino. Ambulance service and fire hydrants were provided in 1963. An emergency medical technician came on board in 1970. But people could not dial 911 in Sedona for another 10 years.

In the late 1950s, residents decided it was time for a library. The recently established chamber of commerce donated space in its building in 1958. This headquarters was only 195 square feet, and the library occupied only a few shelves, allowing room for 200 volumes. Ground-breaking for a new building in 1968 included a speech by Sen. Barry Goldwater. It was fitting that he spoke again, at the opening of the next library building in 1994.

View of Uptown, c. 1940. In the early 1940s, there was no Uptown Sedona. The area consisted of only a handful of homesteaders' and farmers' homes and Charley Thompson's store and post office. After the construction of Midgely Bridge, road improvements, and the re-routing of the canyon road, a highway soon attracted businesses and changed this rural landscape forever.

Frank Thompson Homestead– Jordan Place, 1920s–1930s. Until the middle of the 20th century, Greater Sedona had remained mostly rural, with agriculture as the mainstay of the local economy. But in the 1950s, homesteads and farms gradually gave way to development. Some property owners sold their land to replace their farming income or to move away. The post–World War II era would see major changes in the population and their reasons for coming to Sedona.

THE REA POWER PLANT, 1947. This war-surplus generator, supplied by the federal government's Rural Electrification Administration, brought electricity to the residents of the Red Rock area. The 60-kilowatt machine created power for about 100 families. Fred Schuerman remembers working for the REA surveying and staking power lines. Arizona Public Service bought out the co-op in 1955.

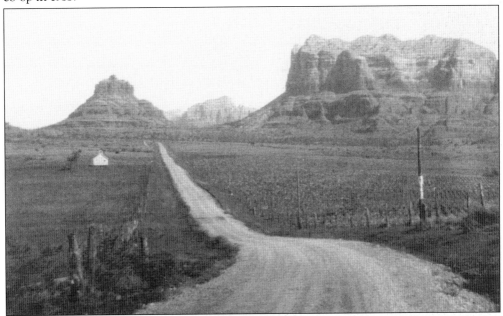

BIG PARK, 1940s. The last remaining major parcel of residential property in the entire Oak Creek–Sedona area was the Fanny Gulick estate in Big Park. In 1967, a Phoenix-based company announced a master-planned, 920-acre residential recreation resort to be known as the Village of Oak Creek. Plans included an 18-hole golf course, shopping center, skeet range, tennis courts, swimming pools, bridle paths, and an upland game club.

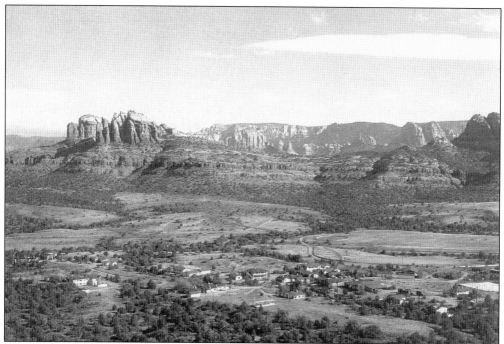

THE VERDE VALLEY SCHOOL, FOUNDED IN 1948. Hamilton and Barbara Warren founded this college preparatory school, which admitted both boarding and day students. Their dream was to bring together talented young people from around the world and ask them to build and to study, to work and to learn, such that they could change the world for the better. It has gained an international reputation over time.

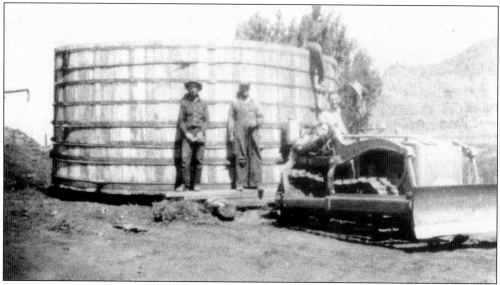

GEORGE JORDAN'S WATER TANK, 1940s. Since the earliest days, Oak Creek settlers got their water from the creek and irrigation ditches. George Jordan piped water to wood water tanks at the top of a hill in Uptown, installed pipes, and created the town's first public water system. The water was filtered by a layer of sand in the bottom of the tank. The Arizona Water Company acquired the system in 1962.

CARL WILLIAMS DRILLING A NEW WELL, 1950S. Fanny Gulick owned a large part of Grasshopper Flat, but her land lacked water. Her arrangement with Phoenix well-driller Carl Williams was that if he found water, she would pay him. Williams brought in the first successful water well in 1947 and then drilled several other wells in the area. The availability of water led to the development of Grasshopper Flat.

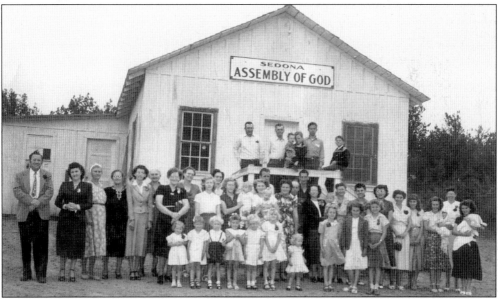

THE ASSEMBLY OF GOD CHURCH, ESTABLISHED 1932. The Assembly of God was the first congregation to construct a building in Sedona for its services. The church was built on leased Forest Service land in the Uptown area. When the congregation could not get additional land for expansion, the group moved. Before its removal, the old building was used by the fire department for sprinkler system testing and firefighting practice.

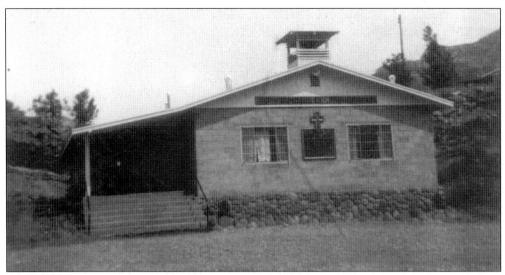

WAYSIDE CHAPEL, 1958. In 1949, this church was built as a non-denominational chapel "along the wayside" of the highway through town. The town's first congregation, the American Sunday School Union, began meeting in the Sedona School in 1918 and then moved around. When George Jordan donated land, the congregation raised the money for this building. The bell was purchased with Sedona Schnebly's memorial funds and dedicated to her.

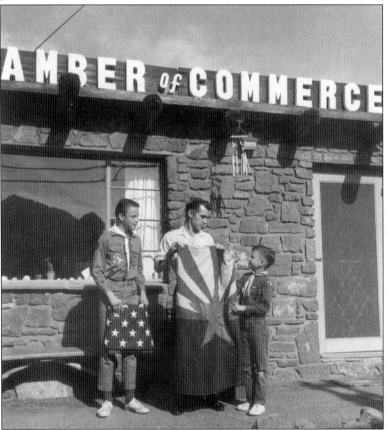

THE CHAMBER OF COMMERCE'S ROLE. Situated in an unincorporated town with no local government and an area spanning two counties, the chamber of commerce was established less as a promotional organization than as an unofficial government and "instigator of community betterment projects." Some of the chamber's first actions were starting a town clean-up program, lobbying for road improvements and television service, and establishing a volunteer fire department.

SEDONA'S POST–WORLD WAR II DEVELOPMENT. The addition of water to Grasshopper Flat, exposure through the movies, and promotion from the chamber of commerce all led directly to development. In 1952, the chamber received 1,000 inquiries from people interested in Sedona as a place to live or visit. Oak Creek Knolls, the town's first planned subdivision, sold 95 percent of its lots in the first year. Developers advertised an "active retirement lifestyle, summer home retreat and headquarters for artists and writers."

CARL RICHARDS'S GARAGE AND SEDONA'S FIRST FIRE DEPARTMENT. Though a cowboy, Carl Richards ended up in Sedona as a blacksmith and mechanic in 1933. He poured the footing for his new garage in 1945. When the town's first fire truck arrived, he volunteered to keep it in his garage. A story circulates that a firefighter had to get the key from Richards whenever there was a fire.

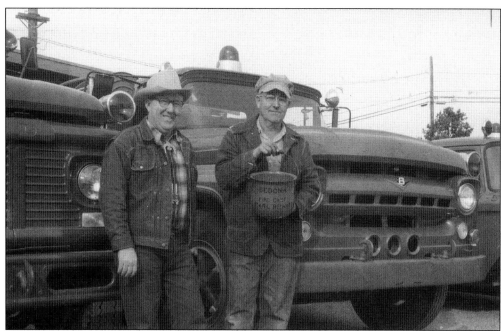

DON HOEL (LEFT) AND CARL RICHARDS WITH THE DONATION POT. In 1948, Sedona lost its school to fire. The chamber of commerce recognized the need for local fire protection and started a firefighting fund. Richards was appointed fire chief and, in jest, given a red chamber pot. He pitched in the first dollar toward a fire truck and equipment.

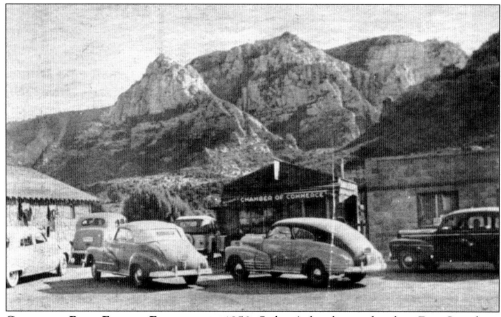

CRENSHAW REAL ESTATE, ESTABLISHED 1950. Sedona's first licensed realtor, Faye Crenshaw, moved to Big Park in 1945. After working on some movies, she realized what the film industry would do for Sedona's growth. She opened her office in Uptown with a sign reading "chamber of commerce, notary public, public stenography, income tax, insurance and real estate." At the time, home lots sold for about $150 and a homestead for $3,500–7,000.

LITTLE HORSE PARK, 1950. Lee Piper patented on his homestead in Little Horse Park in the late 1930s. The area was also home to several movie sets, partly because it was surrounded by large, scenic Sedona rock formations and partly because it was undeveloped except for the Piper house. After construction of the Chapel of the Holy Cross, the natural park sprouted houses.

MIDWIFE NETTIE VAN DEREN, EARLY 1900s. Home remedies were the most common medical treatments in pioneer days. Today some of them seem more dangerous than the maladies they were supposed to treat, such as kerosene and sugar for the croup. Sedona resident Nettie Van Deren was well-known for her home remedies and her skills as a midwife. Nettie delivered many local babies, as did "Aunt" Lydia Brewer.

SEDONA'S FIRST DOCTOR, 1955. Beginning in 1865, the military doctors at Fort Verde were sometimes available to civilians. The mine in Jerome brought medical personnel to the area in the early 1920s. Dr. Leo Schnur left his position as medical director of the Grand Canyon hospital to open Sedona's first practice. Because of Dr. Schnur, medical specialists from Phoenix began seeing patients in his office on a consulting basis.

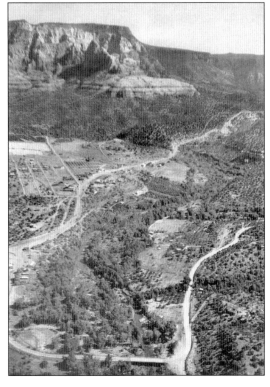

OAK CREEK DEVELOPMENT, 1950S. In 1950, Sedona's population was only about 350 people. An increase in homes and motels meant more septic tanks, many near Oak Creek. The need for an integrated sewage management and treatment system would eventually be the crux of residents' decision to incorporate as a city. Oak Creek was designated a "Unique Waterway" by the Arizona State Legislature in 1991 for its recreational and ecological importance.

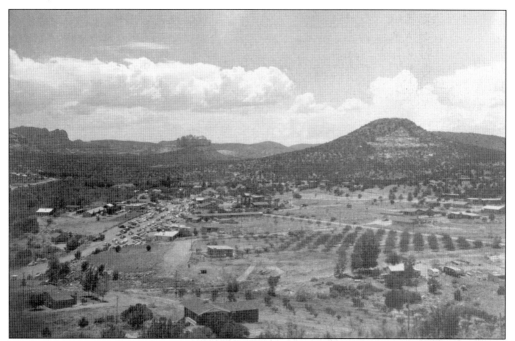

UPTOWN TRANSITIONS FROM AGRICULTURAL TO COMMERCIAL, 1950S. This view, taken from water tank hill, shows the proliferation of new businesses along the highway in Uptown and a smattering of new homes in the Van Deren subdivision. Parts of the Jordan family orchards still exist here but are slowly being squeezed out by growth.

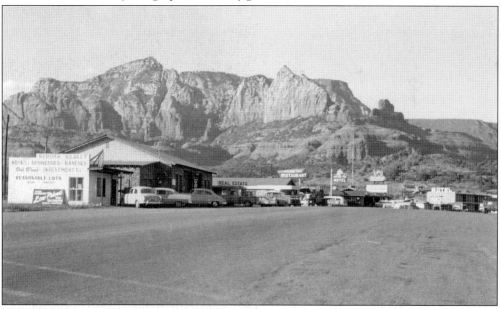

UPTOWN BUSINESS DISTRICT, 1957. Beginning with the establishment of Charley Thompson's store and post office in 1938, Uptown became Sedona's central business core. Unlike today's tourist-based business mix, it used to be a typical small-town shopping district with a shoe store, clothing stores, banks, gas stations, a drugstore, and even a bus stop, with homes scattered just beside or behind the small businesses.

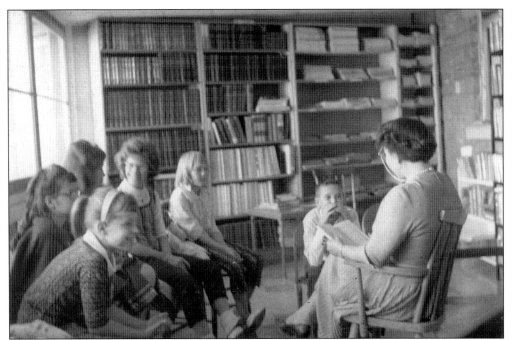

LIBRARY STORY TIME, 1964. A state bookmobile used to come to the area every six weeks before 1958, when the chamber of commerce donated space for 200 titles. This was Sedona's first library. The institution moved several times, always borrowing space. In 1964, the Friends of the Library was activated, hours were extended, and a Saturday children's story hour was added to library services.

SEDONA PUBLIC LIBRARY UNDER CONSTRUCTION, 1969. The library has always been a community effort, not a government service. Residents raised all the funds for their first new library building, constructed on Jordan Road and opened in 1970. The construction crew was made up mostly of hardworking volunteers and retired professionals and businessmen. Except for the stonemasons, the only paid worker on the job was a carpenter.

SEDONA AIRPORT'S FIRST HANGAR, 1956. Joe Moser and Ray Steele, both pilots, used a bulldozer to make a landing strip on the top of Table Top Mesa about 1955; they later added a road up the side of the mesa. Planes that flew in and needed gas were asked to circle the town a few times so Joe could see them from his Shell station. He would then take fuel to them.

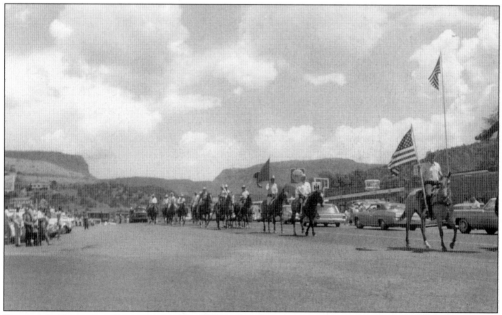

SEDONA'S SENSE OF COMMUNITY. In 1953, a local group known as the Oak Creek Rifles staged a parade for a movie crew—and got paid for it. The club would become the Coconino County Sheriff's Posse, and for many years, the posse grounds hosted the town's parade and rodeo. Civic, professional, and social clubs have proliferated with the population. Cooperation, good deeds, and traditions add to Sedona's small-town character.

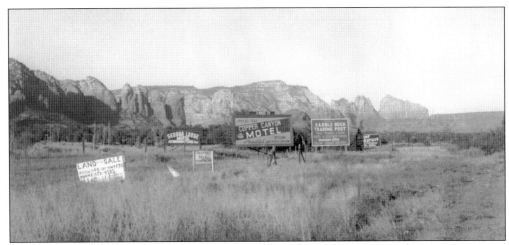

SEDONA'S BEAUTIFICATION MOVEMENT. The Sedona Garden Club appealed to the chamber of commerce to curb the growing billboard blight that threatened Sedona's scenic views. In 1957, Operation Clean Up voluntarily eliminated almost 100 percent of roadside signs. In 1967, the town was recognized by the national Cleanest Town Conference for its efforts. Some still say the town is almost militantly determined to preserve the area's natural beauty.

LEGACY OF VOLUNTEERISM. Sedona's history of volunteerism, perhaps rooted in the self-sufficiency of the area's earliest settlers, also stems from being unincorporated until relatively recently. Being governed by two counties just added to the need for citizens to organize themselves in all manner of ways to meet the needs of the community. Volunteer activities continue for nearly every taste, and there are seemingly infinite ways to be involved.

126

BIBLIOGRAPHY

Benore, Loretta. *In Days of Yore* (column). *The Villager* newspaper, 2002.

Bradshaw, Bob. *Westerns of the Red Rock Country*. Sedona, AZ: Bradshaw Color Studios, 1991.

Jordan, Ruth F. *Following Their Westward Star*. Self-published, 2005.

Kindig, Jean Matthews. *Sedona Area Places and Names*. Self-published, 2006.

McNeill, Joe. *Sedona Monthly Magazine*, September 2005 and 2006.

Myrtle Nail Smith Archives. Sedona Heritage Museum.

Purtymun, James "Bud." *Arch of Time, 1875–2002: Sedona, Oak Creek*. Sedona, AZ: self-published, 2002.

Sedona Historical Society. *The Sedona Filmography and Videography*. Sedona, AZ: Jim Eaton, 2006.

Sedona Westerners. *Those Early Days: Old-timers' Memoirs*. Sedona, AZ: The Verde Independent, 1968.

Thorne, Kate Ruland. *The Legacy of Sedona Schnebly*. Sedona, AZ: Thorne Enterprises, 1994.

Verde Valley Pioneers Association. *Pioneer Stories of Arizona's Verde Valley*. Camp Verde, AZ: self-published, 1954.

THE AUTHORS. Janeen Trevillyan (left) is shown at the Sedona Heritage Museum. Lisa Schnebly Heidinger (right) is shown on Schnebly Hill Road.

ACROSS AMERICA, PEOPLE ARE DISCOVERING SOMETHING WONDERFUL. *THEIR HERITAGE.*

Arcadia Publishing is the leading local history publisher in the United States. With more than 3,000 titles in print and hundreds of new titles released every year, Arcadia has extensive specialized experience chronicling the history of communities and celebrating America's hidden stories, bringing to life the people, places, and events from the past. To discover the history of other communities across the nation, please visit:

www.arcadiapublishing.com

Customized search tools allow you to find regional history books about the town where you grew up, the cities where your friends and family live, the town where your parents met, or even that retirement spot you've been dreaming about.